CAPTURING MOTION IN WATERCOLOR

DOUGLAS LEW

WATSON-GUPTILL PUBLICATIONS / NEW YORK

Copyright © 1987 Douglas Lew

First published in 1987 in New York by Watson-Guptill Publications,
a division of Billboard Publications, Inc., 1515 Broadway,
New York, N.Y. 10036

Library of Congress Cataloging-in-Publication Data

Lew, Douglas.
 Capturing motion in watercolor.

 Includes index.
 1. Watercolor painting—Technique. 2. Movement,
Aesthetics of. I. Title.
ND2420.L48 1987 751.42′2 87-15947
ISBN 0-8230-0557-7

Distributed in the United Kingdom by Phaidon Press Ltd., Littlegate
House, St. Ebbe's St., Oxford

Manufactured in Japan

First printing, 1987

1 2 3 4 5 6 7 8 10/92 91 90 89 88 87

CAPTURING MOTION IN WATERCOLOR

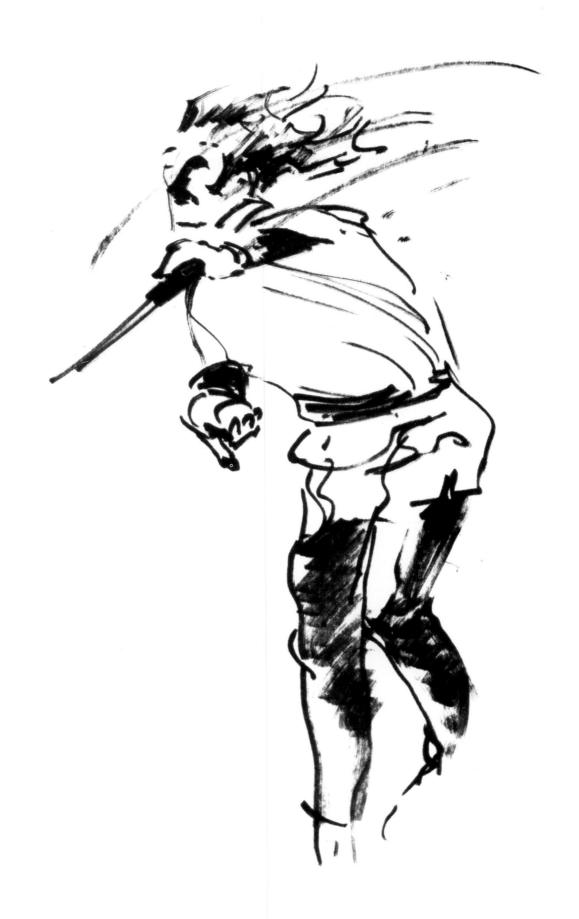

CONTENTS

INTRODUCTION 7

DRAWING 8
Figures 8
Animals 19
Landscapes 24
Other Possibilities 28

TECHNIQUES OF MOTION 30
Calligraphy 30
Blurs 34
Soft versus Hard Edges 38
Abstraction 40
Streaking 44

USING THUMBNAILS 48

MOTION STEP BY STEP 56
Following a Golf Swing 56
Depicting a Horse Race 61
Abstracting Speed 66
Portraying a Sailing Race 69
Focusing on Birds in Motion 72
Working with a Group of Figures 77

PUTTING IT TOGETHER 80
Creating an Impression of Speed 82
Capturing a Moment of Tension 98
Conveying Excitement 104
Choosing a Bold Composition 110
Getting It Right 122
Suggesting Mood 128
Using Calligraphy 136

A FINAL WORD 140

MATERIALS 142

INDEX 144

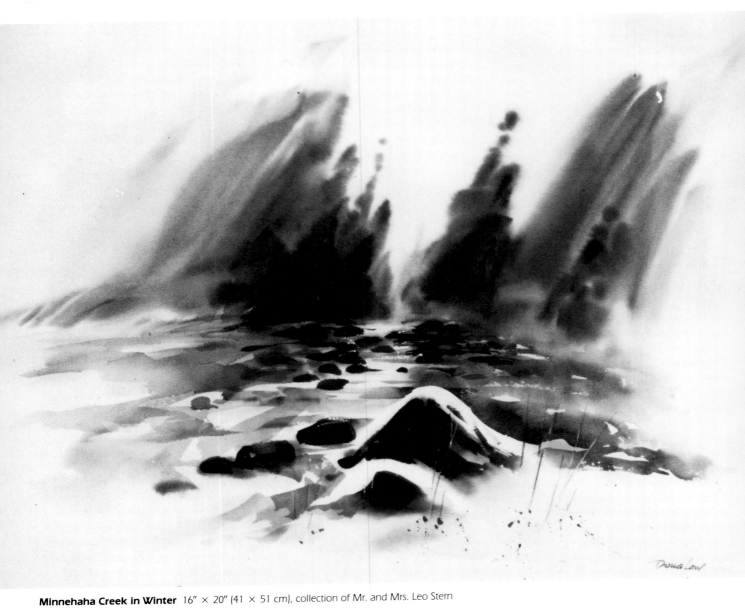

Minnehaha Creek in Winter 16" × 20" (41 × 51 cm), collection of Mr. and Mrs. Leo Stern

INTRODUCTION

I was born in China and lived in Shanghai until 1948, when my family immigrated to America. All children in China, before and during the War, were required to practice calligraphy daily—one page of small characters and two or three pages of large characters. This was usually done at home, after school, to be handed in the next day. We copied the classical examples given to us in several styles. The exercise, which took about an hour, was designed to train students to write legibly. Any Chinese child who had an interest in art was thus already quite proficient with a brush.

Calligraphy is truly an art form in itself. One can easily observe qualities of continuity, balance, strength, individuality, and verve. Master calligraphers write maxims and poetry in large characters on scrolls to decorate walls. Calligraphy is also often an integral part of a painting. Words are written on a painting to explain or comment on it, or to commemorate the receiver of the painting. Interestingly, the word for classical landscape painting in China translates as "nature written."

When calligraphy is done quickly, it is referred to as "grass writing." Abbreviations are formed. The brushstrokes often connect. One can actually feel the speed and fluidity of the dancing strokes.

It is no exaggeration to say that when brushstrokes are deftly executed, they are one of the key elements of motion. After pondering the subject for quite a while, I have come to the conclusion that my method of capturing motion is a unique way of "seeing" things in motion. Take a runner at top speed. One person may see him frozen in a split second with all the details—face straining and contorted, eyes nearly closed, mouth wide open, hair flying, fists clenched, muscles glistening with sweat, bones and veins almost popping through the skin. Another person sees and remembers the rhythm of the stride. Still another person simply sees and registers a blur. All attempts at painting the runner are different re-creations of what different artists see, at a later time, when the action is over. The point is: the runner is the same, but each of us sees him differently.

Today we have the advantage of being able to see and learn from the efforts of all the artists in the past who have tried to capture motion in different ways—from the crude cave painting of animals and hunters to Degas' graceful paintings of horses and dancers. One might compare Michelangelo's massive contorted figures, the lilting qualities of Baroque painting, the swaying figures of Rubens, or, more recently, Duchamp's *Nude Descending a Staircase*. But now we also have the advantage of photography to enhance our perception of motion. The wonderful documentation of people and animals in motion by Muybridge was a first step toward the beautiful slow motion of high-speed cinematography. Through photography, our vision of motion has already been greatly extended, and, with advances in technology, it should continue to expand, enabling us to analyze motion in a way never before possible.

One day I was sitting in a dark room, working with a film editor. He stopped the machine momentarily to discuss a sequence. There on the monitor was a "still" but blurred image of a boy running in a field of tall grass with a dog. I was caught as much by the feeling of speed as by the abstract quality of the image. I borrowed the frame from the editor and took it home so I could study the picture from a painter's point of view. I loved the feeling of motion, but that frame was not well composed. The distribution of light and dark was spotty, and there was no focal point. What I subsequently did with paint and paper was, for me, a new way of looking at motion—but within the context of art.

I must stop and emphasize this last point. For if I succeed in only demonstrating the techniques of motion to you, then you will have only received half the value of this book. I hope you will also learn and practice the basic principles of art as discussed throughout the book.

Obviously I don't need to tell you about the joy of watercolor. I'm sure you have already experienced it yourself—the sweaty palm, the nervous excitement, the hesitation, the initial commitment, the frustration, the glimpse of promise, the exhilaration, and that inner satisfaction. Did I describe it accurately? But there is more. You will learn, for example, that a loosely painted figure demands stronger drawing; that mastering the technique is only half of a painting. You will find out how to work that technique into a well-composed picture. And finally you'll discover that special feeling of joy deepened.

DRAWING

There are thousands and thousands of painters out there, starting, struggling, succeeding, exhibiting, teaching, and dabbling in all kinds of media: oils, acrylics, watercolor, pastels, gouache, inks, mixed media, electricity, and even computer graphics. Sooner or later they all grapple with some basic principles of art—namely, color, composition, form, shape, value, and drawing. The most neglected is drawing. I think I know the reason. First, it's the most difficult. Second, we are in a period of art where anything still goes. It's become all too easy to dazzle the public without the need of drawing.

All the preceding periods of art, from the time of the ancient Egyptians to the Post-Impressionist period, have had their own standards. Drawing was required in all of them. Today, however, free-flowing color, shapes, and texture, without the underpinning of drawing not only decorate homes but grace walls of museums as well. The confused public can't get a clear statement about art from the connoisseurs or critics because they themselves don't agree.

At the risk of offending some fellow artists I will simply say that drawing will always be one of the basics of art. We begin by drawing much as a baby learns to crawl before walking, as a musician practices scales before a performance, as an athlete exercises his moves before a contest, or as a writer reads before writing. It's that fundamental.

Drawing becomes particularly important when we deal with the subject of motion because in most instances the subject is barely suggested. Details are deliberately omitted in order to create the feeling of movement. Without a thorough knowledge of drawing, one is hard put where to place those few crucial strokes to make the presence and attitude of the subject known. In a way you must engage in a hide-and-seek game to convey the feeling of motion. What to hide and what to reveal depends on how well you know the subject—and knowing the subject well means knowing how to draw well. I'm sure you've heard the expression, "What is left out is as important as what is put in." The viewer has an amazing ability to fill in what is left out provided you supply a minimum of information with knowledge and skill.

Figures

If you can draw figures well you can draw anything. Figures are the most difficult to do well, and errors are easy to detect. Viewers will accept a lot of mistakes in a landscape—whether in the perspective, shadows, or proportions, but they will instantly recognize an error in a figure, and they can even describe it.

The discipline and demands of figure drawing are great. I urge you to practice drawing as often as you can. Don't belabor the drawings. Think of them as exercises.

You might begin by copying figures from magazines and newspapers, which are readily available. Draw quickly and often, trying to capture the proportion and gesture correctly. Do the same figure again and again. You'll be amazed how quickly you will improve from one sketch to the next.

In addition to drawing single figures, work with a group of figures or a crowd. This will force you to simplify. Also practice drawing from life, sketching family members or friends reading or doing quiet chores. This, too, will sharpen your power to observe and simplify.

The most difficult exercise is to draw from moving figures. What I do is to pick a moment in a sequence of a motion, visualize it sharply in my mind, and then sketch it as quickly as possible. Often I practice drawing in front of a TV, so I still have the pleasure of watching Wimbledon or the U.S. Open. Try it sometime. If you find it difficult to keep up with the moving figures, just wait—sooner or later the figures will come back to the same pose.

Draw figures standing, sitting, and walking. Try to capture the attitude, the stance. It's more important than the nose or the eyebrow. Think of the last time you were walking on a busy street. Suddenly, at a distance, a figure darted across the street and you recognized him as your dad, or your Uncle Bob, or your Cousin Bill. You couldn't have seen his eyes; he was too far away. It was something about his shape, his posture, or his gait that you recognized, wasn't it? Well, draw that.

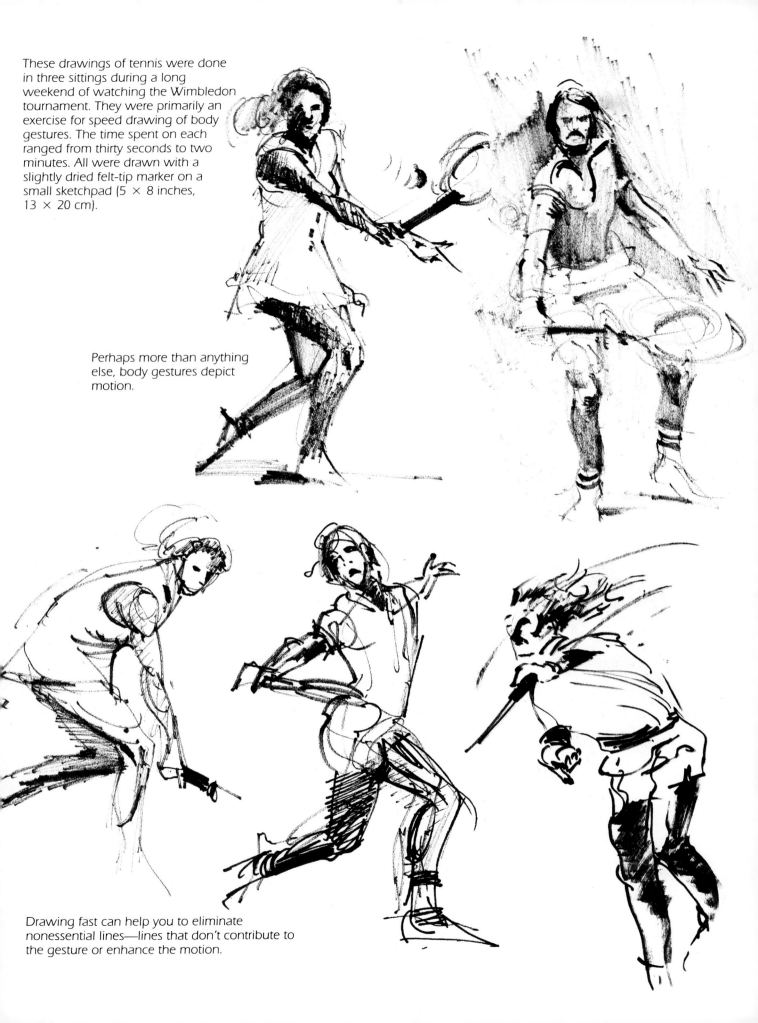

These drawings of tennis were done in three sittings during a long weekend of watching the Wimbledon tournament. They were primarily an exercise for speed drawing of body gestures. The time spent on each ranged from thirty seconds to two minutes. All were drawn with a slightly dried felt-tip marker on a small sketchpad (5 × 8 inches, 13 × 20 cm).

Perhaps more than anything else, body gestures depict motion.

Drawing fast can help you to eliminate nonessential lines—lines that don't contribute to the gesture or enhance the motion.

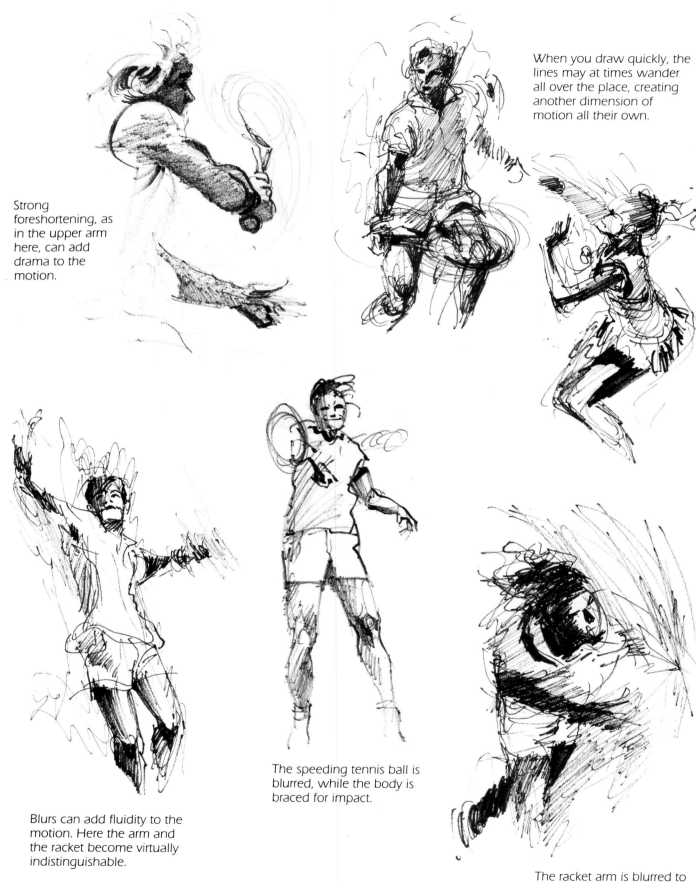

Strong foreshortening, as in the upper arm here, can add drama to the motion.

When you draw quickly, the lines may at times wander all over the place, creating another dimension of motion all their own.

Blurs can add fluidity to the motion. Here the arm and the racket become virtually indistinguishable.

The speeding tennis ball is blurred, while the body is braced for impact.

The racket arm is blurred to accentuate the force of the smash.

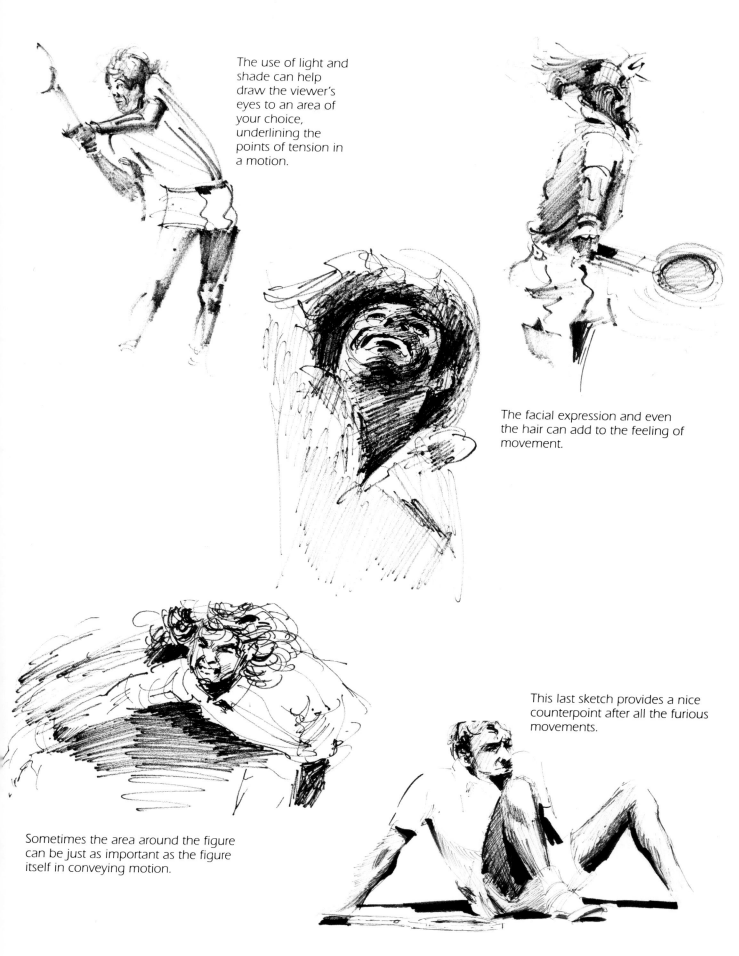

The use of light and shade can help draw the viewer's eyes to an area of your choice, underlining the points of tension in a motion.

The facial expression and even the hair can add to the feeling of movement.

This last sketch provides a nice counterpoint after all the furious movements.

Sometimes the area around the figure can be just as important as the figure itself in conveying motion.

For these sketches I switched to pencil and began to suggest a background. You can see the start of composition. The gesture and movement are enhanced by the shading around the pitcher's hip and golfer's elbow. That's one of the advantages of pencil—that you can establish subtle values quickly and accurately as you begin to construct your composition.

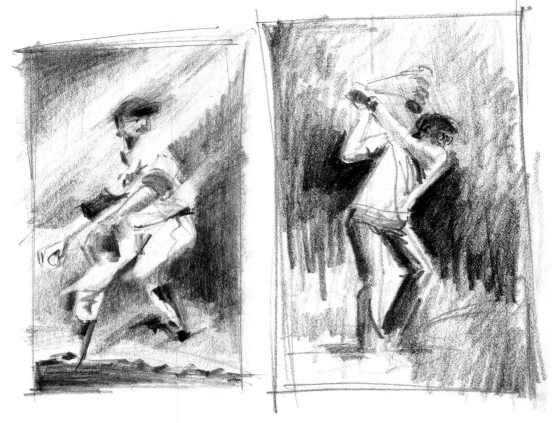

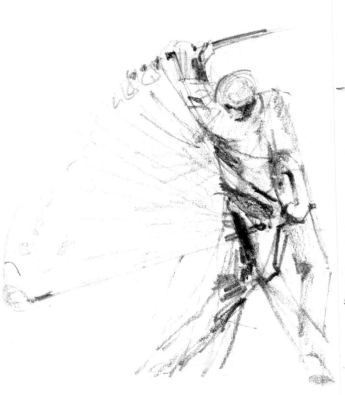

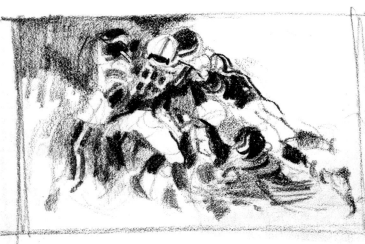

In this tangle of figures all you need is a suggestion of a helmet or two to identify the game of football. On the right, the figure with his feet off the ground is plunging into the melée. This makes everything move, especially as the other figures are blurred and barely distinguishable.

This sketch is an exercise in combining the various stages of a golf swing in one drawing. As you can see, the head remains stationary, but the shoulder and knee positions change as the weight is shifted from one hip to another.

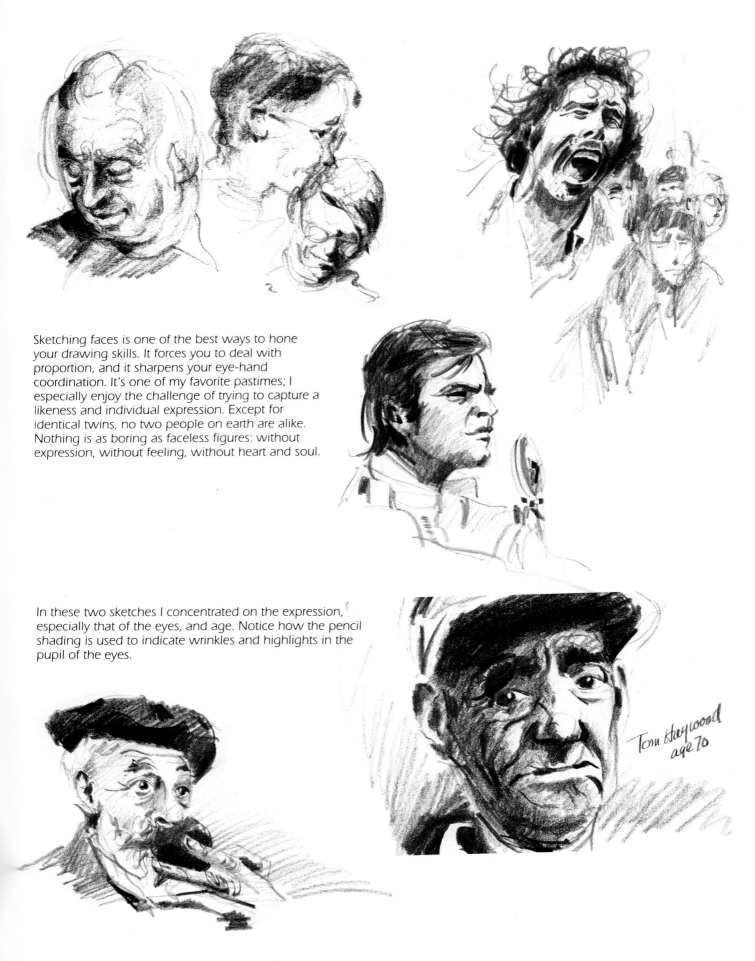

Sketching faces is one of the best ways to hone your drawing skills. It forces you to deal with proportion, and it sharpens your eye-hand coordination. It's one of my favorite pastimes; I especially enjoy the challenge of trying to capture a likeness and individual expression. Except for identical twins, no two people on earth are alike. Nothing is as boring as faceless figures: without expression, without feeling, without heart and soul.

In these two sketches I concentrated on the expression, especially that of the eyes, and age. Notice how the pencil shading is used to indicate wrinkles and highlights in the pupil of the eyes.

Tom Haywood
age 70

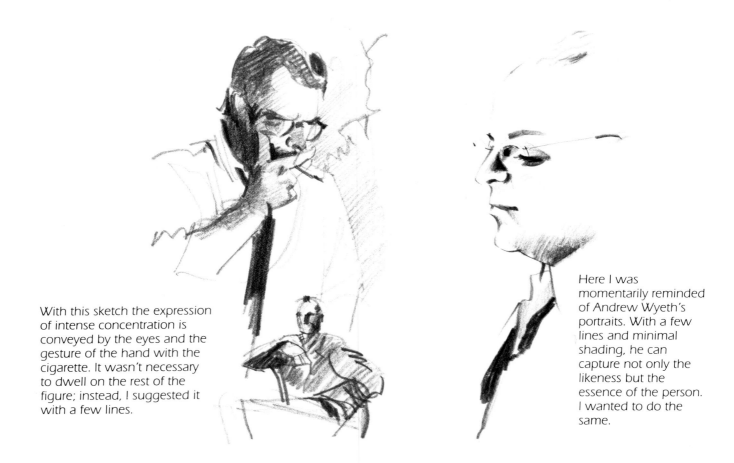

With this sketch the expression of intense concentration is conveyed by the eyes and the gesture of the hand with the cigarette. It wasn't necessary to dwell on the rest of the figure; instead, I suggested it with a few lines.

Here I was momentarily reminded of Andrew Wyeth's portraits. With a few lines and minimal shading, he can capture not only the likeness but the essence of the person. I wanted to do the same.

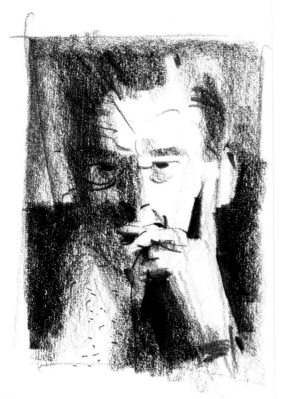

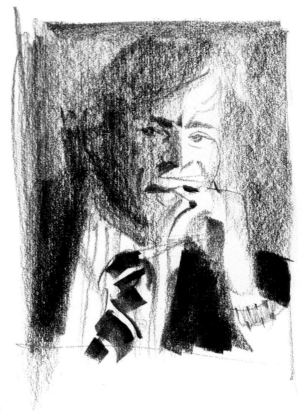

In these last two drawings I used a broad, 6B chisel-edged pencil to see how quickly I could capture a likeness. I was going after the essence of the person rather than a detailed likeness.

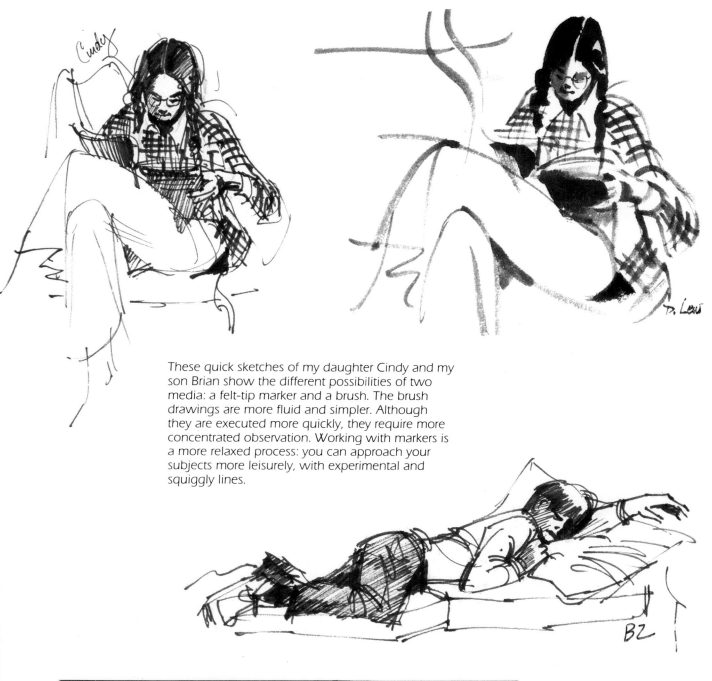

These quick sketches of my daughter Cindy and my son Brian show the different possibilities of two media: a felt-tip marker and a brush. The brush drawings are more fluid and simpler. Although they are executed more quickly, they require more concentrated observation. Working with markers is a more relaxed process: you can approach your subjects more leisurely, with experimental and squiggly lines.

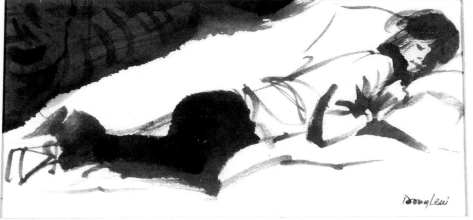

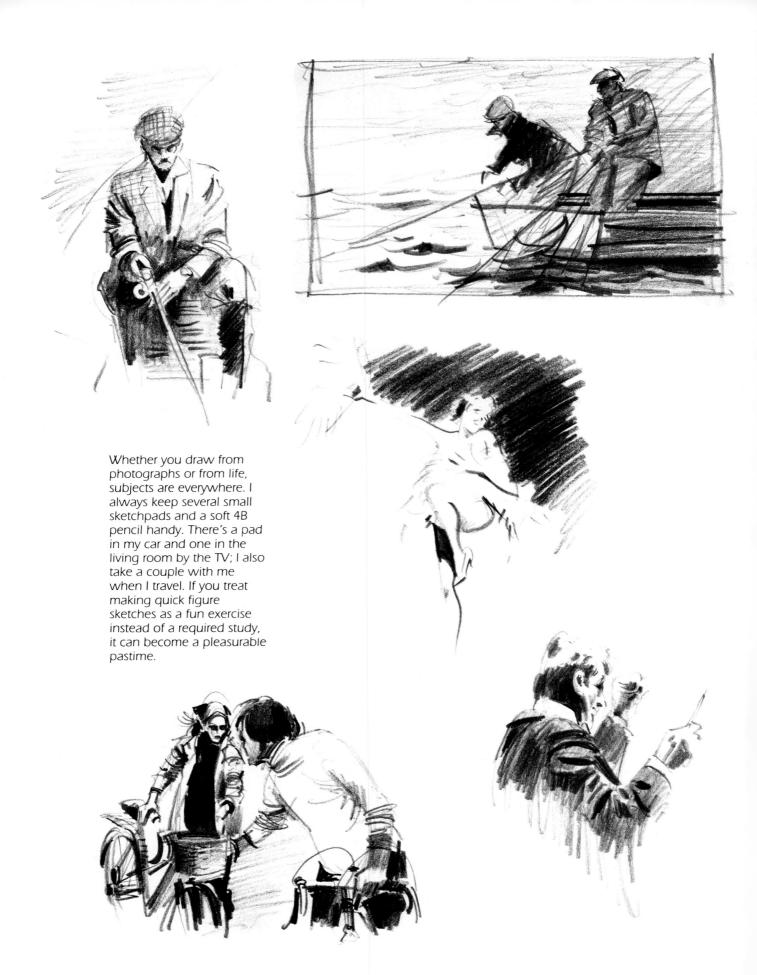

Whether you draw from photographs or from life, subjects are everywhere. I always keep several small sketchpads and a soft 4B pencil handy. There's a pad in my car and one in the living room by the TV; I also take a couple with me when I travel. If you treat making quick figure sketches as a fun exercise instead of a required study, it can become a pleasurable pastime.

Look for characteristic
gesture or attitude of a pose.
If you're sketching a seated
figure, it helps to indicate
whatever the person is
sitting on.

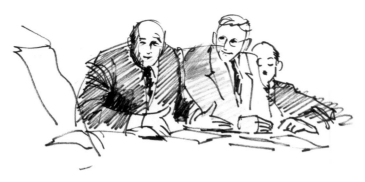

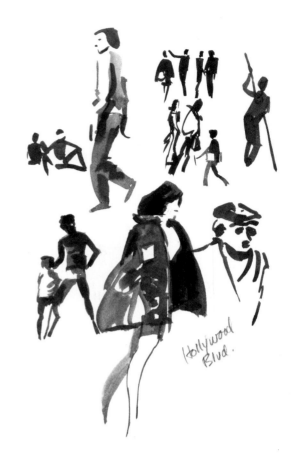

Having a sketchpad handy made these drawings possible. The first was done watching a dull business presentation. The second was done at a Paris sidewalk cafe; the third was done sitting in a car on Hollywood Boulevard. As always, I do a better job when I'm not watched.

You must capture gestures accurately before you can integrate them into a composition of motion. Studies of individual figures, like the ones here, are important in developing a more complete painting idea.

Animals

Animals are a natural subject to draw if you are interested in motion. Even when they are still, there are opportunities to suggest motion. You might, for example, emphasize the curly hair of a dog or use a combination of curving, waving, and straight lines to hint at the potential for movement in an animal's overall shape. Of course, it's difficult to get animals to pose, so photographs provide a rich source of information. And photographs can be especially useful to urban artists, who do not have easy access to animals except as pets or at the zoo.

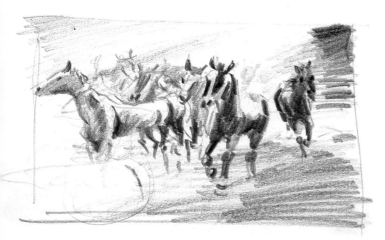

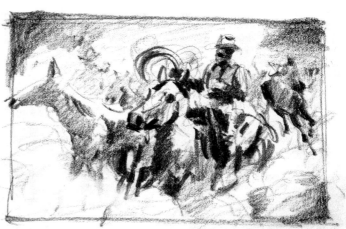

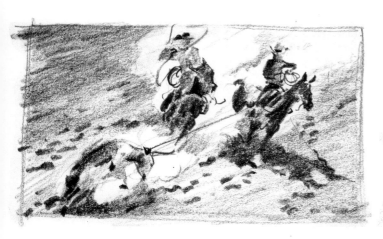

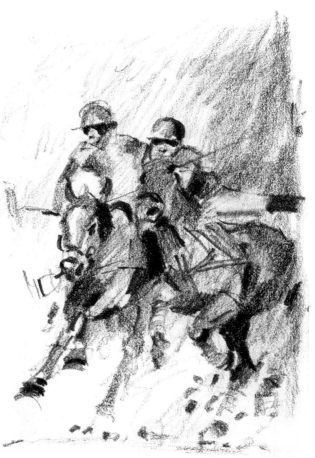

My fondness for horses is apparent. They are such marvelous animals to watch and to draw, and the next best exercise to figures in terms of proportion, action, and perspective. In these sketches, which were preliminary drawings for paintings, notice how the patterns of light and dark contribute to the feeling of motion.

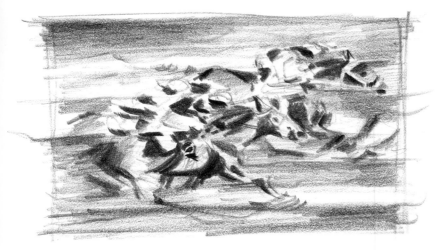

This sketch represents an attempt at abstraction. Although there is a quality of lost-and-found, the sense of speed and motion is maintained by the horizontal masses streaking past the viewer.

These brush drawings, with their simple values, were an attempt to see if I could capture gestures even faster than with a pencil.

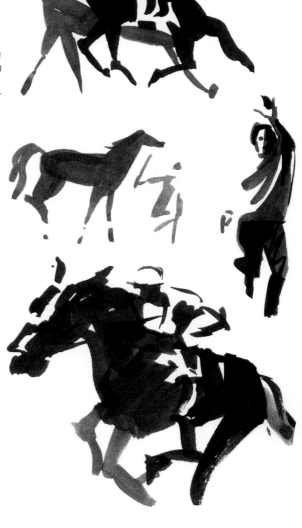

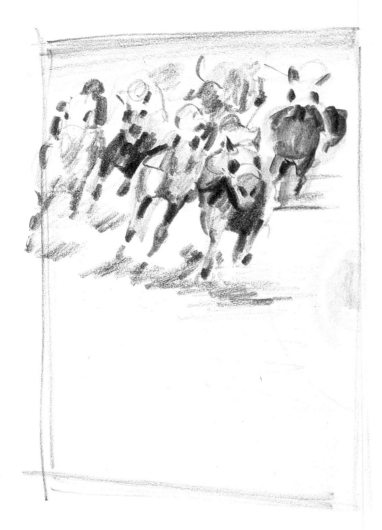

Here the perspective, with the horses racing head-on toward the viewer, adds to the feeling of motion. Notice how few details are needed to suggest the subject.

These two sketches are preliminary drawings for paintings using birds in flight as subject matter. In the first the birds are lightly indicated, so they blend into the background. In the second, although the birds are only incidental elements to the seascape, they do add "life" to the scene.

The lines formed by the birds are deliberately repeated elsewhere to add to the feeling of flight.

Wildlife painting is very popular in the Midwest. Often, however, it is too tightly rendered for my taste. In contrast, my sketch of a pheasant is fairly loose. Later, as I painted the bird, the sketch served to remind me of two points: (1) not to complete the bird in every detail and (2) to repeat colors and brushstrokes from the bird in the background for a more integrated painting.

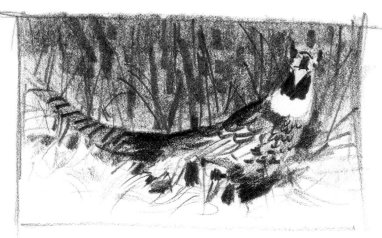

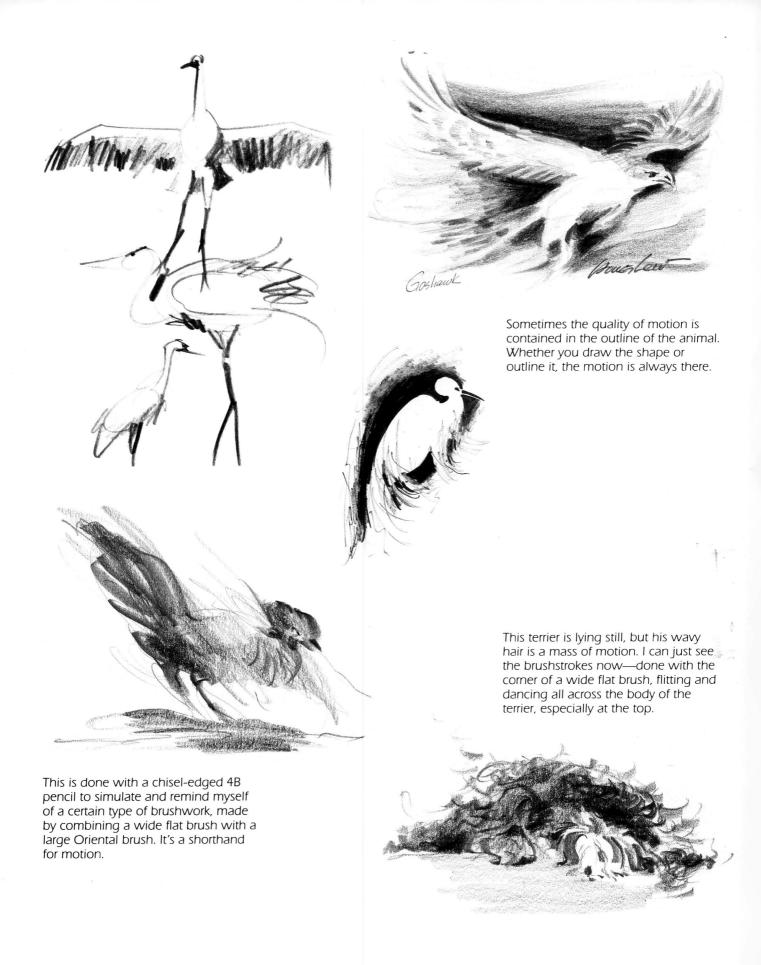

Goshawk

Sometimes the quality of motion is contained in the outline of the animal. Whether you draw the shape or outline it, the motion is always there.

This terrier is lying still, but his wavy hair is a mass of motion. I can just see the brushstrokes now—done with the corner of a wide flat brush, flitting and dancing all across the body of the terrier, especially at the top.

This is done with a chisel-edged 4B pencil to simulate and remind myself of a certain type of brushwork, made by combining a wide flat brush with a large Oriental brush. It's a shorthand for motion.

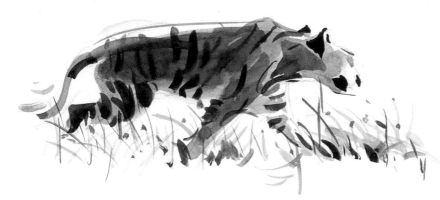

The feeling of motion is mainly carried by the stance of the animals: the two hyenas stalking, the elephant at work, and the bears at play.

Landscapes

Although people and animals are most readily associated with motion, they are by no means the only subjects. Landscapes, for example, contain many elements of motion. Think of water, wind, sky, trees, and leaves—or, more specifically, the moving shadows on a sun-dappled road or the hustle-bustle of an urban street.

Sometimes a dramatic sky can take on a look of movement simply by the way it is drawn or painted. A loaded brush, dripping wet, applied with a flourish can make a sky look amazingly alive with motion. Another way to give a landscape a sense of motion is by using a dramatic and exciting composition. Just as composition can suggest quiet and peace, it can also be arranged to create energy, tension, and movement.

My intention here was to blur the hill and the tree on top of it into the fog-shrouded background. The moving elements were the wind-blown tree on top of the hill and the gently lapping water around the rocks in the foreground. Although the blurring technique is more apparent in the final painting, it is still visible in the sketch.

The trees on the coast at Monterey, California, are often shaped by the winds. They move simply by standing still—a truly wondrous and eerie sight. You can draw them just as they are, or you can exaggerate the twisting limbs as they bend in the constant wind.

Clouds move rapidly during a storm. Even this sketchy record lays the foundation for a sky in motion. The storm-laden clouds are blown from right to left in great force, churning upward. The motion almost carries the ground up with it.

Water is seldom still. Motion is immediately created by the slightest disturbance. The infinite degrees of disturbance are eternally fascinating to artists. As this sketch indicates, you can suggest waves of water with a flat chisel-edged pencil. Using all sides of the chisel will give you the rippling effect of the water.

This time the movement of the water is set against the backdrop of Venice. The water here is relatively still, but the placement of the gondola against the arch of the bridge creates more movement in the composition. The contrast of the darks to the right and under the bridge against the large and slightly undefined area to the left generates tension, adding to the feeling of movement.

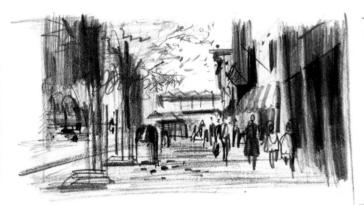

Street scenes are full of movement. Leaves flutter in the wind; flags gently wave; plus there's the hustle and bustle of the people. Although a quick sketch like this may not capture all this movement, it can help by establishing a compositional underpinning for movement.

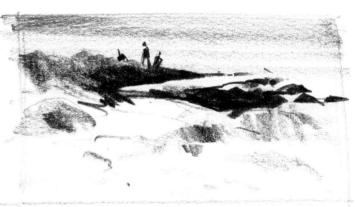

For details of the water, I usually look at photographs, but this drawing defines the composition better—and that's its purpose. All I need is a reminder of the crashing of the waves against this rocky coast.

The tree limbs that snake across this scene weave a motion by themselves. At the same time they define the drawing's composition.

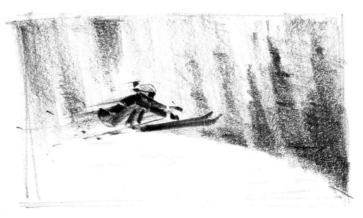

The blurring of the trees behind the skier immediately suggests motion.

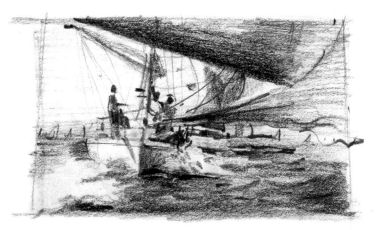

One of the joys of drawing is the liberty you can take in changing things. Here I shifted the sails in a diagonal direction to dramatize motion and to achieve a more dynamic composition.

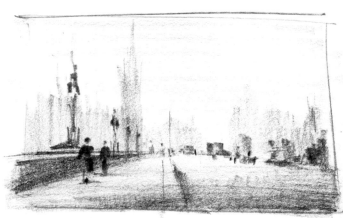

This is London. You're looking at Big Ben from the approaching bridge. I purposely left out the details of the cars and buses to heighten the sense of motion in the traffic and offset a fairly static composition.

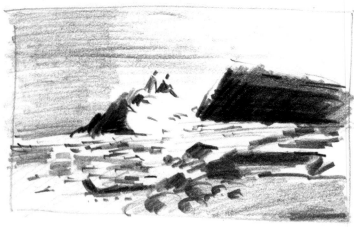

This drawing is a mental note to myself to use a broad, wet-brush approach to heighten the direction of the water from left to right. A brush drawing would be better. But in an emergency, anything will do.

Savarah

When the wind is blowing in one direction against a fountain, trees, and people, the feeling of motion is quite obvious. The direction of the lines conveys this in the drawing.

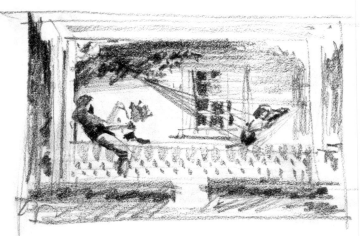

A suspended object, like this hammock, sets up a feeling of motion. To augment this implicit feeling of motion, I might add a blur in painting this subject.

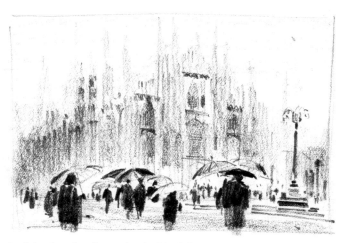

In this sketch of a cathedral in Milan on a rainy day, the hurried gestures of the crowd carry the feeling of movement. The different angles of the umbrellas also enliven the scene.

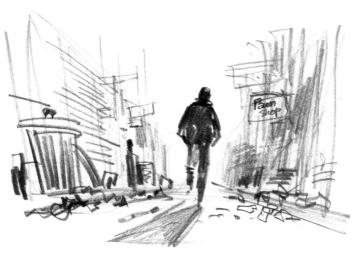

I wanted the motion of this drawing to come not only from the walking figure, but from the garbage and litter around him as well. The distorted perspective also adds to the feeling of motion.

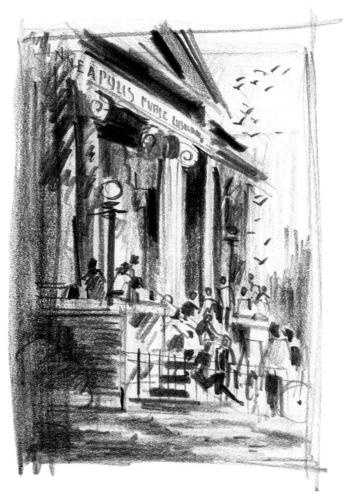

The solid mass of this building is relieved by the busy, milling crowd. The pigeons add even more motion and a sense of lightness.

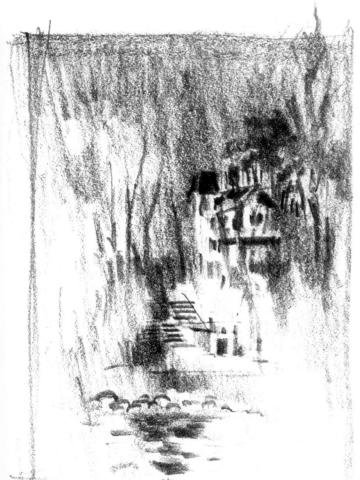

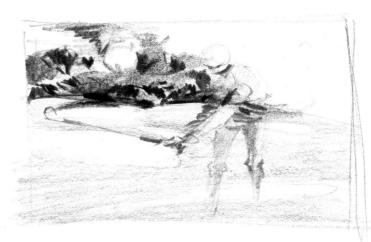

This house is perched amid thick trees on top of a hill overlooking a lake. I wanted to created a vertical feeling of motion to enhance the height of the building. Notice the pencil lines are mostly up and down. The spreading tree branches have been almost eliminated to further accentuate the up-and-down movement.

This drawing is a preliminary attempt at making an abstract painting of a golfer. I've included it in a discussion of landscape because the figure is beginning to blend into the background. The movement of the club starts to form the shape of a sand trap.

Other Possibilities

Anything can carry a feeling of movement, even inorganic things such as a building, a machine, or a piece of hanging fabric. One way to suggest motion is by minimizing the definition of the subject and introducing a broad, vigorous wash or streaking lines. You can also render the subject with lively, rapid lines or brushstrokes.

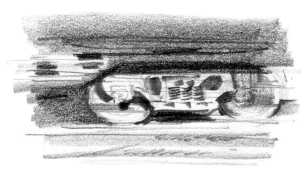

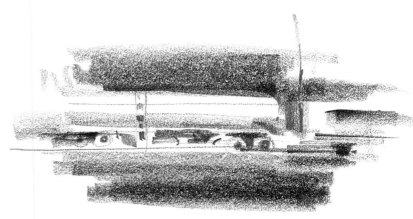

These two drawings—of a truck and the wheels of a train—are exercises in abstraction. I wanted to see how little I could indicate to suggest something. Abstracting in this way often results in a feeling of motion because in motion we see very little detail. You might try this with similar objects to the ones shown here. Draw only enough for viewers to recognize what the subject is; then add or surround it with some moving lines or tone.

The undulating folds have a movement of their own. Folds are hard to do from memory, but if you draw them often enough, your memory is sharpened. Although they have no life they do have a special kind of motion. The lines would be quite different for crinkled and creased paper or for soft tissue paper wadded together. Try it. It's a fun exercise and very useful.

Just a few lines indicating the spray of water are enough to suggest the movement of the car along the wet street.

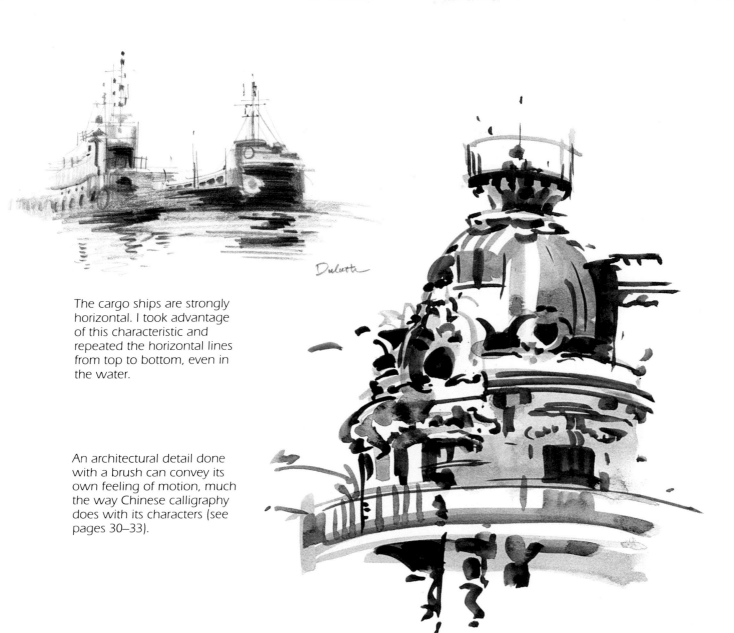

The cargo ships are strongly horizontal. I took advantage of this characteristic and repeated the horizontal lines from top to bottom, even in the water.

An architectural detail done with a brush can convey its own feeling of motion, much the way Chinese calligraphy does with its characters (see pages 30–33).

Although this sketch shows an anchored boat, there is a hint of potential motion. The diagonal pattern of the sail carries a strong directional force.

TECHNIQUES OF MOTION

Most of the techniques discussed in this section are probably already known to you, with the possible exception of streaking. Even Chinese calligraphy is not new. What I intend to do is to show you, in a clearer fashion, the connection between a feeling of motion and calligraphy, wet-in-wet, and other watercolor techniques.

The essential thing to realize is that watercolor is a fluid medium. Its very nature wants to move. Without control, it crawls, drips, and oozes by itself. The same characteristic that makes it hard to control lends itself naturally to motion.

The second thing to realize is that our idea of motion has changed as a result of film and photography. I suspect our notion of movement on a piece of paper is quite different from notions held a century or two ago. Therefore the techniques we are about to discuss must be considered along with the way we are accustomed to seeing motion today. I cannot show you with paint and paper how sound travels through space, but I can give you an idea of what a racehorse looks like charging past you·at forty miles an hour and what methods you can use to simulate that effect.

Calligraphy

Let me begin with my roots. I mentioned in the introduction that I was influenced by Chinese calligraphy and that the practice of calligraphy laid the foundation for my brushstrokes. Let me hasten to add that this is by no means a prerequisite for

learning how to paint watercolor in motion. Indeed, many artists the world over, past and present, have acquired a facility for brushwork with no foundation in Chinese calligraphy. I merely thought it interesting to show the connection.

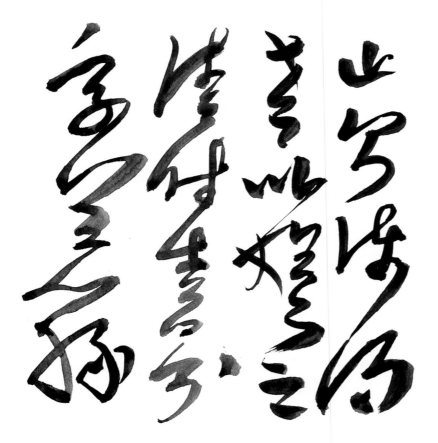

This is my copy of calligraphy by Chen Shen (1483–1544), Ming Dynasty, written in the cursive script of that period. Chen Shen's calligraphy is like his painting—moving elegantly like a racehorse, distinguished and free, replete with natural lyricism. On one occasion his teacher was asked if Chen Shen was his student. The teacher smiled and said, "I was his first teacher. He has his own way with painting and calligraphy. He is no longer my student."

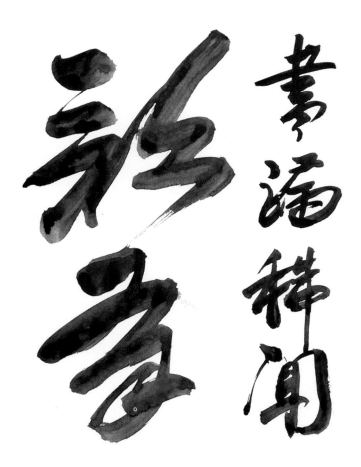

This is my copy of calligraphy by Chang Jui-Tu (1569–1644), Ming Dynasty, written in the running script of that period. Considered one of the four great calligraphers of the Ming Dynasty, Chang Jui-Tu has a solid and bold style. He preferred to use a worn brush with a sharp tip. His broad strokes move with weightiness and angularity, carrying substantial pressure to the end of each line.

The brushwork is quite evident in this sketch, although there is also considerable emphasis on the gesture of the figure. I may have used a few too many strokes, but I gained in the strength of the drawing.

If we were to judge this example by the tenets of traditional Chinese painting, we might ask: "How many strokes did it take to complete this demonstration? Are the brushstrokes clear and evident? Does it express the subject or the painter?" The goal would be to use as few strokes as possible, not to hide any brushstrokes, and to leave the personal hallmark of the painter.

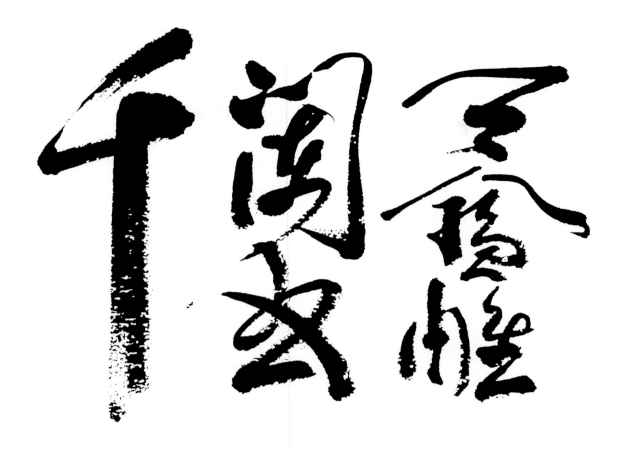

This is my copy of calligraphy by Chu Yin-Ming (1460–1526), Ming Dynasty, written in the cursive script. Notice the drybrush effect in the first example and the fluid harmony of the smaller characters in the second. I should also point out that most Oriental brushes are made with goat hair, so they don't have the resilience of sable brushes. The width, pressure, and strength are readily noticeable in every stroke, demanding control and mastery from the calligrapher.

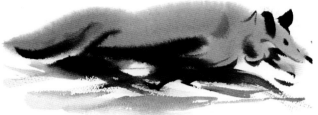

This example shows what I mean by brevity of brushwork. The drybrushed legs of the fox are slightly distorted to give an overall sense of swiftly moving legs. Detailed anatomy would only get in the way of the feeling of moving legs.

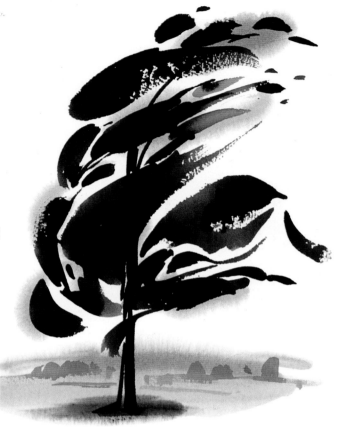

Calligraphy should be used to convey an impression, not to delineate details. Here, for example, the wind-blown effect is obvious. No attempt was made to hide the brushstrokes.

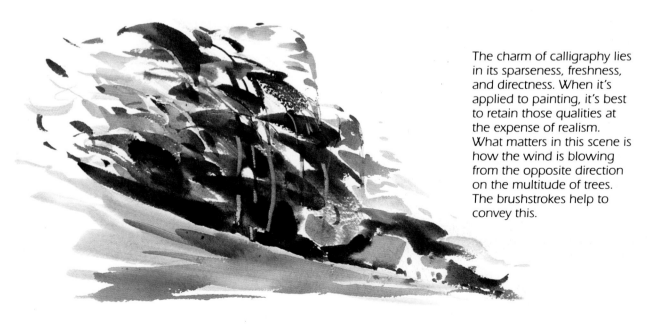

The charm of calligraphy lies in its sparseness, freshness, and directness. When it's applied to painting, it's best to retain those qualities at the expense of realism. What matters in this scene is how the wind is blowing from the opposite direction on the multitude of trees. The brushstrokes help to convey this.

Blurs

Nowadays we tend to associate blurs with motion. Blurs don't have any sharp edges, so wet-into-wet techniques are often used to suggest them. The blurs may occur in the background or in the subject, or they may be used to connect the two.

This is probably the easiest and most common exercise using the wet-into-wet technique. First lay in a flat wash and, before it dries, apply a different wet color in small dabs so there are no hard edges. The second wet color should always be a little less wet than the first; otherwise there will be an undesirable flowering effect.

The only difference with this wet-into-wet technique is that the wash is graded dark to light from the top of the paper to the bottom. The second wet color is also graded from dark to light, but I let the brush move in a free-form way, making connecting and touching strokes. The wetter the second color, the more it will spread.

This is another example of the wet-into-wet technique with a graded wash. Here I let the first wash dry a bit longer than in the preceding example. The brushstrokes are more evident but still soft.

Another technique is painting dry into wet. When the first wash is just about to dry, load your brush with fairly dry pigment and let your brushstrokes dance across the paper. The vigor of the strokes should convey energy and movement.

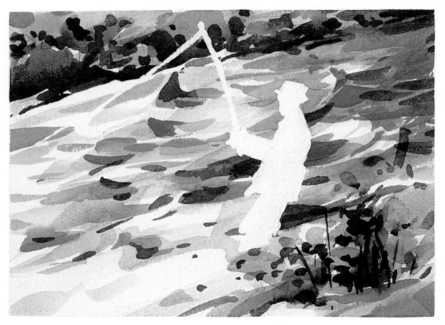

The four techniques just described are particularly good for making the background move. Here I masked out the fisherman and used the same colors in both versions so you can more clearly see the change in the background with the wet-into-wet technique. I also made limited use of the dry-into-wet technique behind the fisherman, to give the rushing water even more vigor and energy.

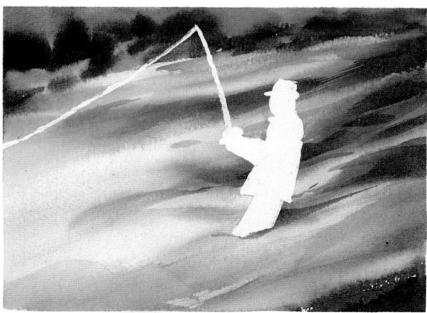

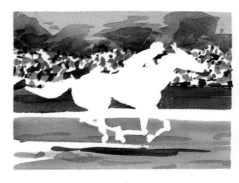

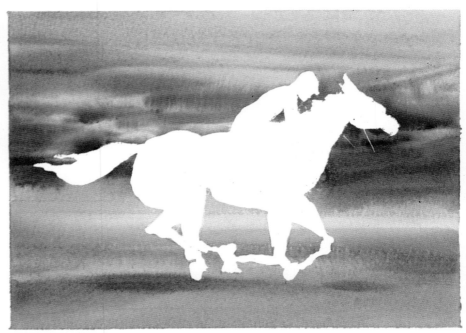

With the horse and rider masked out, you get a clear view of the background crowd and trees in the first version. Notice in the second version, when the background is blurred, how much the motion is enhanced.

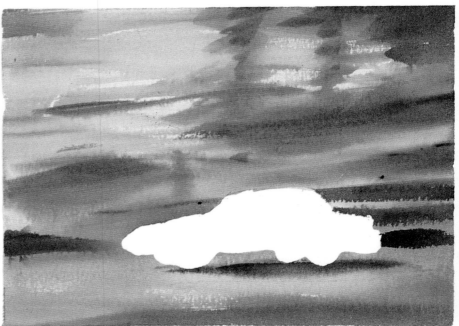

Again, the car is masked out and the colors are kept the same. The one directly above looks quite still, while the one to the right moves.

Notice that the direction of the blur in the background follows the direction of the skier. This isn't always necessary. You can alter the direction in any way you want and still give the illusion of motion.

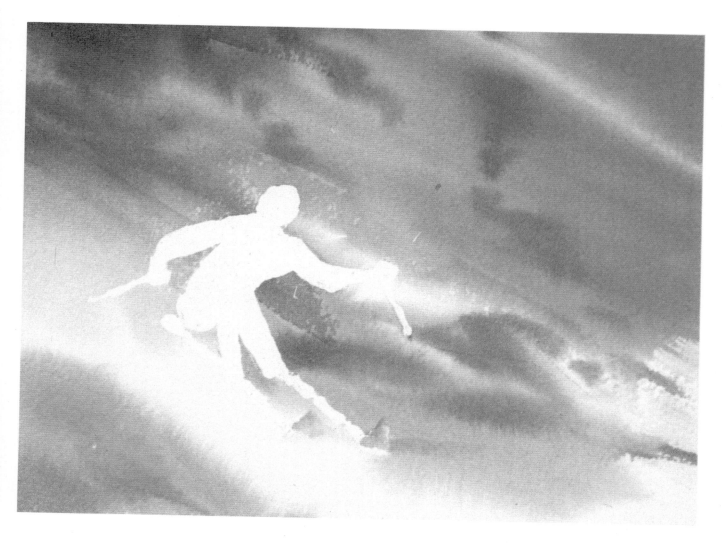

Soft versus Hard Edges

The techniques described here allow you to play soft against hard edges in a traditional use of the watercolor medium. They can be used for just about any painting subject.

This technique—working dry into partial wet—is tricky but well worth the practice. First apply a fairly wet sienna color directly onto a dry surface; then dip the brush in some water and thin out the color. Let the second application of color run into the first and let the brushstrokes trail across the paper. Add orange and repeat the process to vary the color. Here, while everything was still wet, I scraped a few times with a Boy Scout knife to add variety to the movement.

For this brushstroke exercise, first wet the entire surface with clear water. Wait until the sheen of the wetness is gone, then load some yellow ochre onto a big round brush, but don't make it too wet. Apply the strokes quickly in a short, curving pattern. Then immediately repeat this process with burnt sienna, but make the pattern smaller, use fewer strokes, and work less wet. The resulting soft-edge effect is quite useful in painting water and sky.

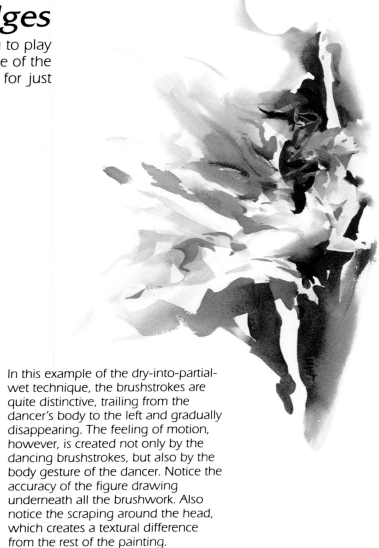

In this example of the dry-into-partial-wet technique, the brushstrokes are quite distinctive, trailing from the dancer's body to the left and gradually disappearing. The feeling of motion, however, is created not only by the dancing brushstrokes, but also by the body gesture of the dancer. Notice the accuracy of the figure drawing underneath all the brushwork. Also notice the scraping around the head, which creates a textural difference from the rest of the painting.

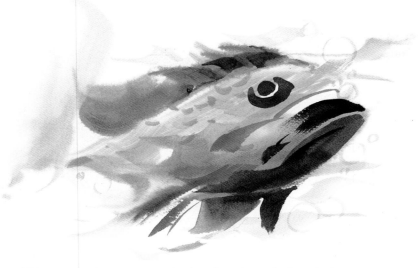

This picture demonstrates the brushstroke technique just described. The pattern of strokes is quite clear on the fish, as well as in the surrounding water. Notice how the brush pattern is repeated, but altered, on the underside of the fish, where I used a flat brush.

The technique used here is essentially the same as in the brushstroke exercise, with some sharp edges added to relieve the monotony of the pattern. Sharpness can also give focus to an area to which you wish to direct the viewer's attention.

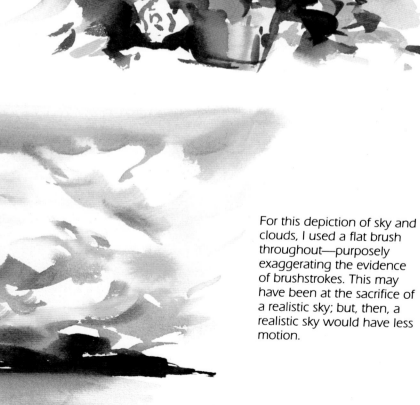

This subject is perfect for the dry-into-partial-wet technique. Just as the shapes of the flower petals and leaves repeat, so do my brushstrokes. Once again, a still subject is made to move through the lively brushwork.

For this depiction of sky and clouds, I used a flat brush throughout—purposely exaggerating the evidence of brushstrokes. This may have been at the sacrifice of a realistic sky; but, then, a realistic sky would have less motion.

Abstraction

Working more abstractly and looking for the relationships between shapes and colors can help you transform more illustrative "motion" techniques into a well-composed painting. And abstraction can enhance the feeling of motion, as some of the following examples show.

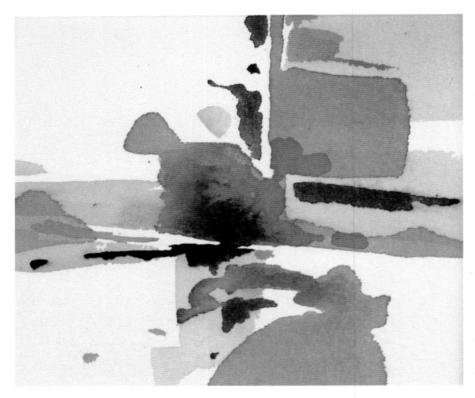

For those of you who have problems with composition, doing abstract exercises like the ones shown here is an excellent way to improve your compositional skills. For once you don't have to deal with realistic shapes and forms. Forget about realism—just concentrate on creating an interesting distribution of shapes and color. As you'll soon discover, there are almost infinite possibilities. It's best to start from large shapes and work toward smaller ones. Also work from light to dark to retain the look of transparency.

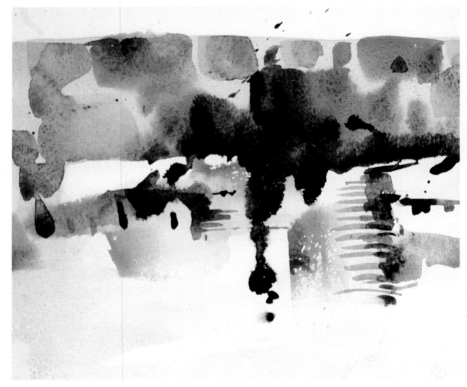

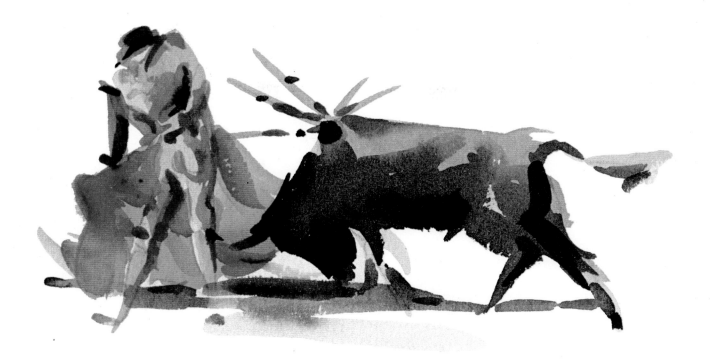

In the second version here I've added a shape on top of the bull and changed the color on its upper body. These changes touch on a basic principle of abstraction—what I've done is to alter realism for a more interesting arrangement of forms. Although the changes are minor, there is a major move toward the making of a painting.

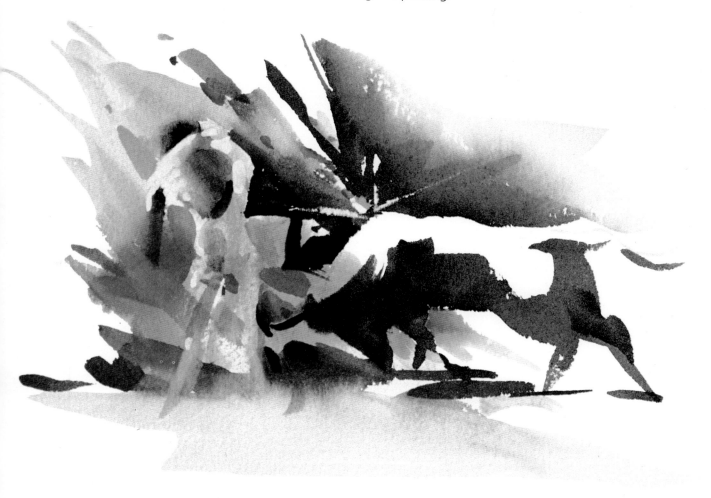

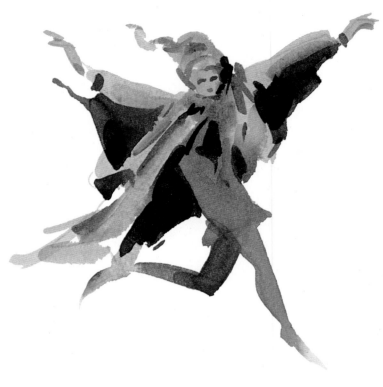

The jumping figure in isolation says "motion," but it's not a painting. In the second version I've added abstract shapes around the figure and altered her front leg from a positive to a negative shape. This kind of playing around with shapes is the beginning of composition. Although the second version is by no means a well-thought-out composition, I'm sure you'll agree it's approaching that. Adding and subtracting colors and shapes can free you from strict adherence to the subject and encourage changes that accentuate motion. Even better, it can help you move from an illustration toward a painting.

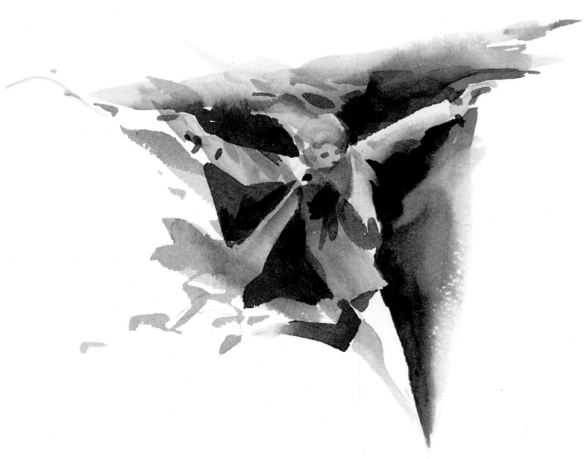

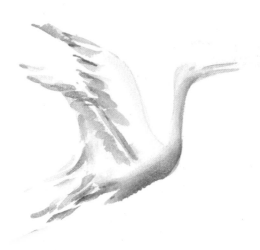

Although the egret on the left moves, it's almost an illustration. The more abstract version on the right begins to approach a painting without losing the feeling of flight. Notice, in particular, the distribution of positive and negative areas and how they interact with each other.

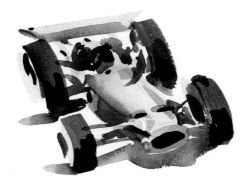

If you were to look only at the picture on the right, I think you would still be able to recognize it as a racing car, but not as instantly as the one directly above. This is another interesting thing about abstraction: its lost-and-found quality. Look at the switch from positive to negative in the wheels. Although this shift obscures recognition, it's somehow more interesting.

Streaking

To experiment with streaking, put a few generous gobs of paint onto a damp surface. Use a squeezed (not wet) sponge and gently drag the paint sideways across the paper. You can also do this with a wide brush. The result is a streaking effect, which feels very much like motion. Don't limit yourself to sideways motion. Wave the sponge or brush; turn it. Make diagonal streaks and curve them to suit the subject matter.

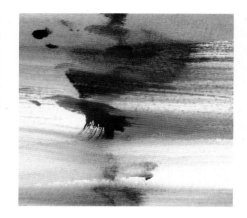

I will never tire of watching this superbly built, magnificently coordinated animal, seemingly incapable of a single ungraceful movement. To get the streaking effect here, I kept the paper damp and used more paint than I would normally do. You'll find that streaking tends to obliterate the form. If that happens, don't hesitate to go back in with more paint to redefine the form. In this example I've also used some scraping and opaque white to bring out the highlights and suggest how the horse's muscles ripple in the sun at full gallop.

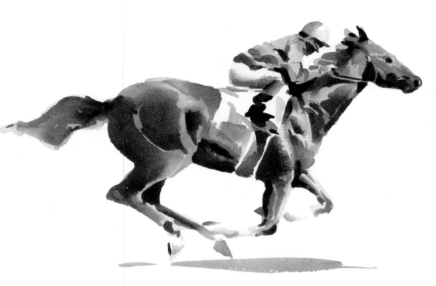

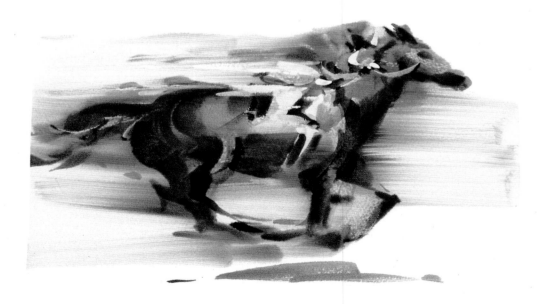

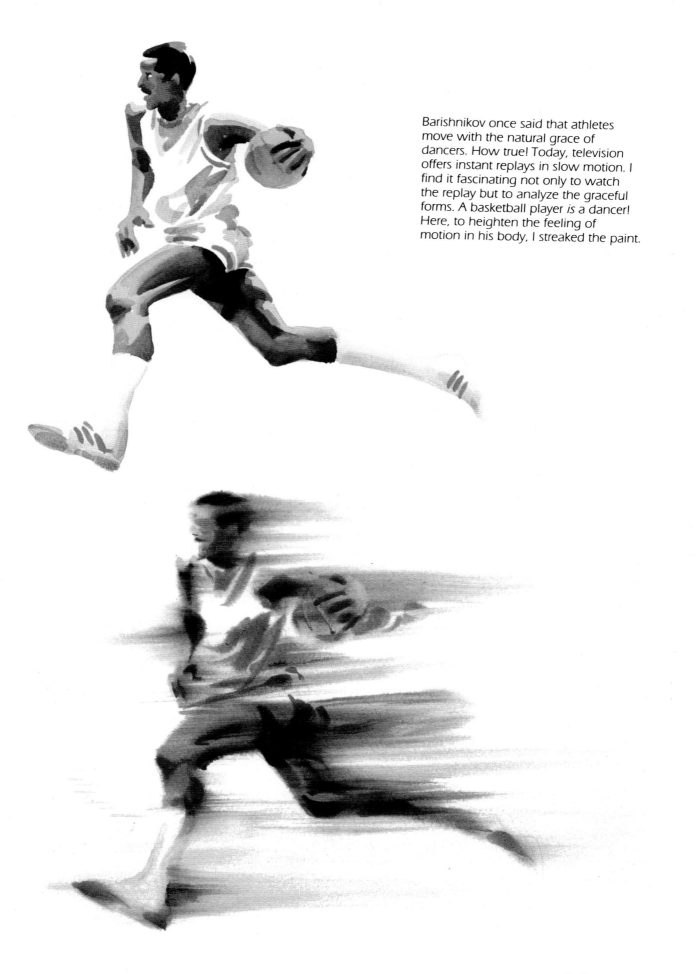

Barishnikov once said that athletes move with the natural grace of dancers. How true! Today, television offers instant replays in slow motion. I find it fascinating not only to watch the replay but to analyze the graceful forms. A basketball player *is* a dancer! Here, to heighten the feeling of motion in his body, I streaked the paint.

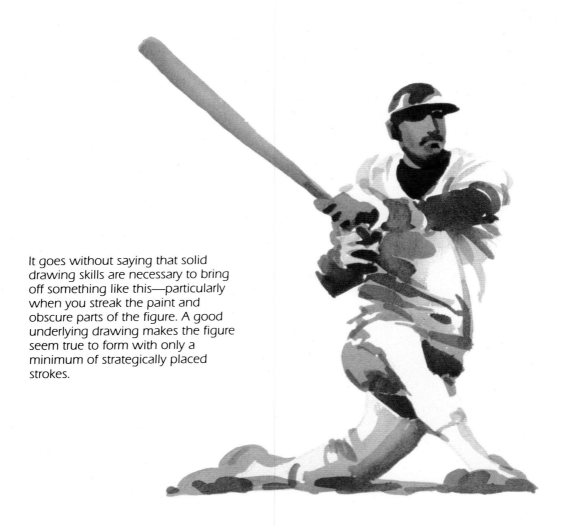

It goes without saying that solid drawing skills are necessary to bring off something like this—particularly when you streak the paint and obscure parts of the figure. A good underlying drawing makes the figure seem true to form with only a minimum of strategically placed strokes.

Even something completely stationary can be made to move. For this example, I worked with a broad brush. Accurate detail was irrelevant. Since what I was interested in was the feeling of speed, the form of the car needed only to be barely suggested. In addition to showing movement, this example reveals the difference between an illustration and the beginnings of a painting.

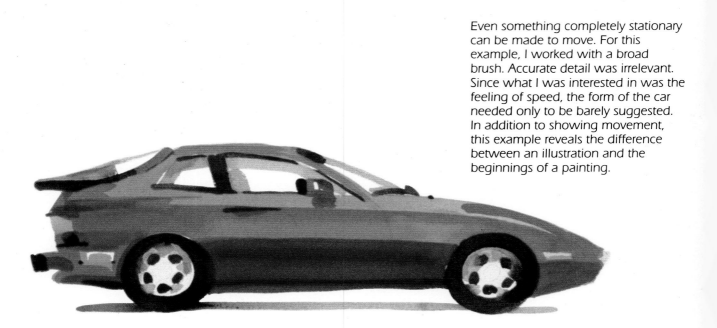

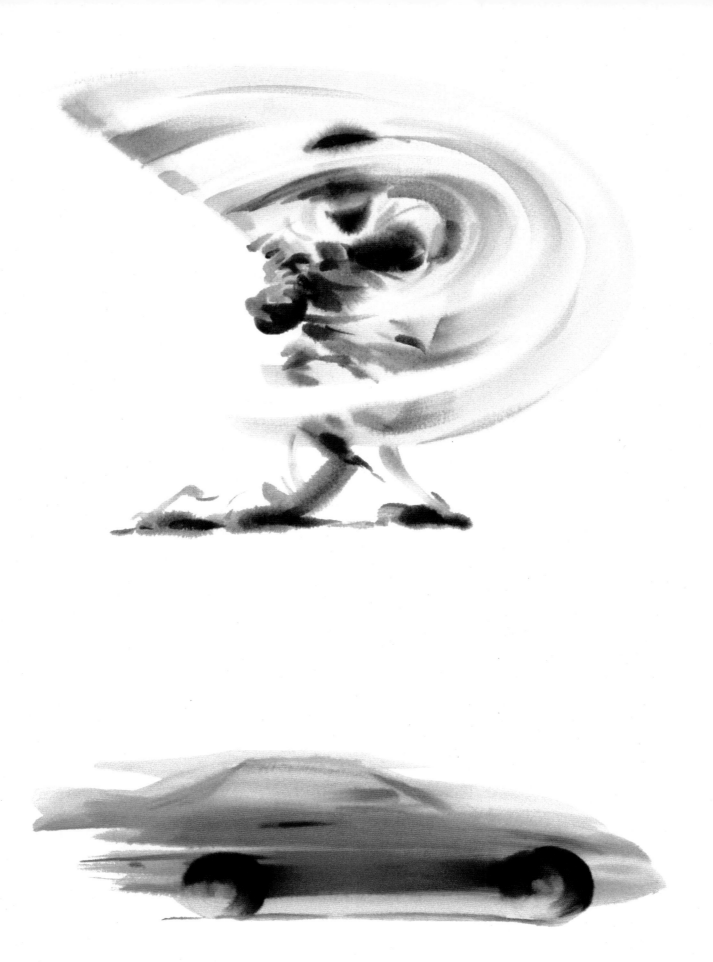

USING THUMBNAILS

Next to drawing, the second most neglected basic in art is composition. This is true even with advanced students or accomplished amateurs. I must admit, I had major struggle with composition years ago when I took up painting seriously again and made a conscious effort to develop my watercolors away from commercialism, toward the fine arts.

One day when I was working in Los Angeles, I gathered all the paintings I had and took them from one gallery to another on La Cienega Boulevard. I told each gallery I wasn't interested in selling my works but only wanted their honest comments. In sum, their reaction was that my paintings were too illustrative. One kind man told me, "Go to the museums; soak yourself in that atmosphere." It was good advice. I prowled the museums and libraries. It took two years before I was totally clear in my own mind what I needed to do to improve my paintings.

In commercial art the application is the main point. Illustration aims to clarify a point or a story. Fine art doesn't need to communicate so specifically or literally. More attention should be paid to composition and emotion. The work should have an intrinsic value without telling a story. Once that was clear I understood immediately the impor-tance of composition, although I am still at a bit of a loss when I have to explain it.

A good way to explore composition is to do small "thumbnail" sketches, about 5 × 7 inches (13 × 18 cm), in pencil or watercolor. You can quickly do several and change the composition at will. This is also the time to explore value and color, to decide whether to do a high-key painting or use more contrast. You'll be surprised at how many little gems emerge from these thumbnails, which may be more spontaneous than the finished painting.

The idea is to use the thumbnail as a roadmap to the final painting, so you can concentrate on the freshest execution possible. It should free you from some important decisions about what to do first, second, and third—decisions that might otherwise compel you to redo a painting two or three times.

Think, for a moment, of the problems in doing a large painting. One of the most vexing problems is how to paint and view something at a distance when the paper needs to lie flat and the execution needs to be swift. I've tried mirrors, reducing glasses, squinting—none of them satisfactory. What this points to is the value of a small sketch. It's a step-saver.

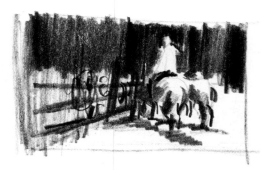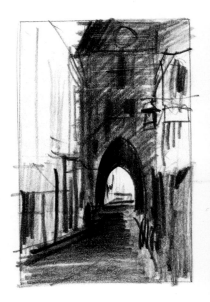

These compositional thumbnails are quick attempts at arranging large shapes and values in interesting and unusual ways. Think of them as foundation blocks for building a painting. As you look at the sketches here, ask yourself: Is there a feeling of balance to the composition? Where is the focal point? Is there a strong directional pull? Learning about composition involves a lot of looking at what works (and what doesn't).

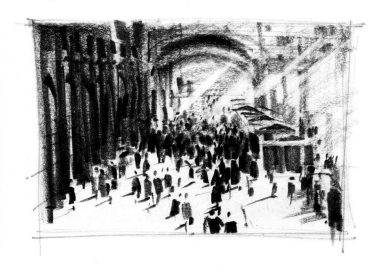

Desembarking

This group of sketches shows the transition from a pencil to a color thumbnail. At the pencil stage it's very easy to explore different formats. In this case I decided the vertical format was closer to the feeling of movement I wanted. Then, as I worked in color, I tried to make the crowd carry the motion. In the last sketch, however, the people are too sharply defined. It serves as a reminder that the crowd should be rendered more softly.

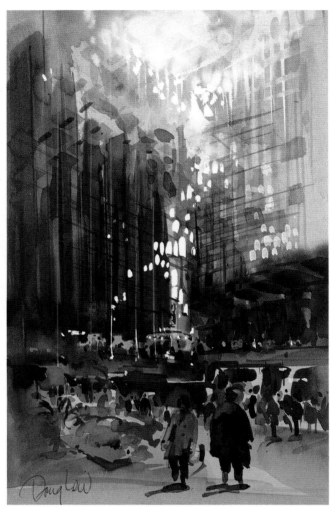

In this scene the feeling of movement comes primarily from the play of light on the glass building. In developing the color sketch into a painting, I would carry the shimmering light down further to give greater lightness and movement to the whole picture.

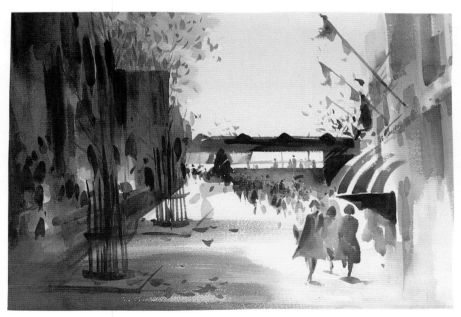

Sometimes there may be major changes between the sketches and the final painting. Here, for example, I shifted to a warm color scheme and lightened the left side, so I could show more commotion on the sidewalk.

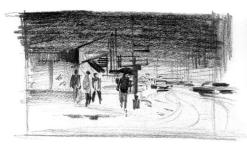

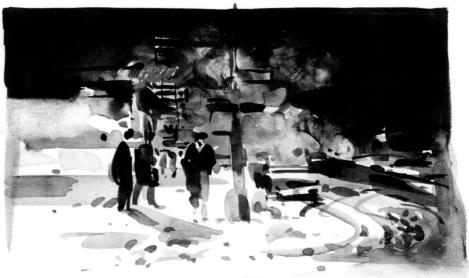

In the pencil sketch I established the large areas of light and dark. Then, in the color sketch, I explored the look of a snowy night with steam rising from the ground.

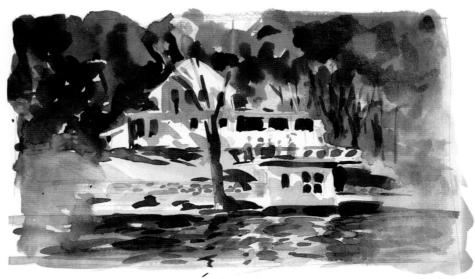

In the color sketch I strengthened the composition of the initial sketch by darkening the background trees.

Sometimes you may want to explore two entirely different color schemes, as I did in these sketches.

I have yet to do a final painting from this series of four thumbnails on Venice—one of my favorite cities to visit and paint. Water is everywhere in Venice. And where there's water, there's motion. It will be a challenge to retain the freshness of these little sketches (4 × 5 inches, 10 × 13 cm) in a final painting.

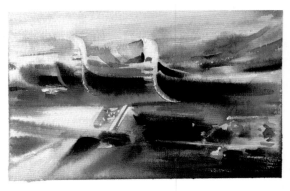

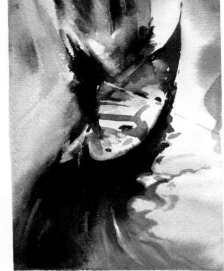

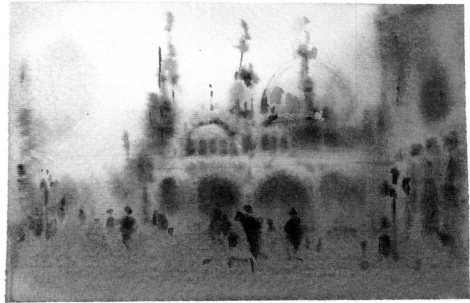

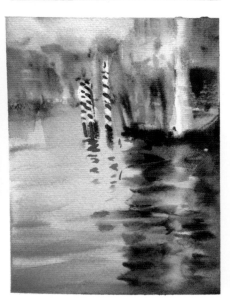

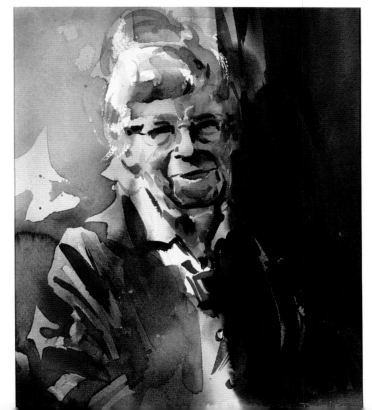

This sketch, done for a portrait finished in acrylic, shows a free use of moving brushstrokes. The only thing I need to correct is the position of the woman's mouth, which should be more centered.

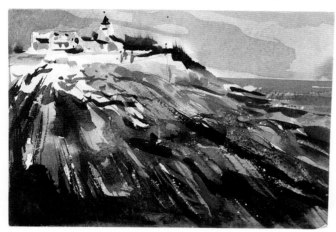

The wet, rocky foreground provides ample opportunity to explore motion and texture. The horizon line, however, need not be so clear.

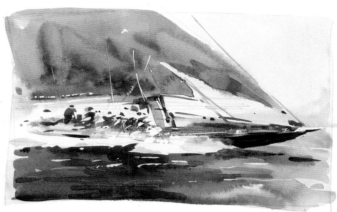

I love the way the motion of the boat almost shoots off the page. Some complementary colors could be spotted in the figures to add richness to the color. Another one I have yet to paint.

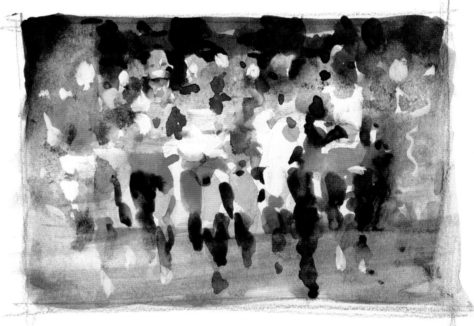

I wanted the motion to come across by more than just the gesture of the runners. The abstraction certainly helped.

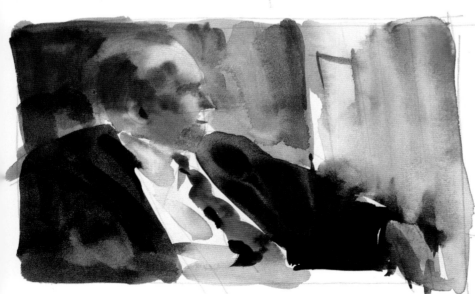

These two figures seem well composed in terms of the distribution of light, dark, and middle tones. Notice how the loose brushwork creates a crisp spontaneity.

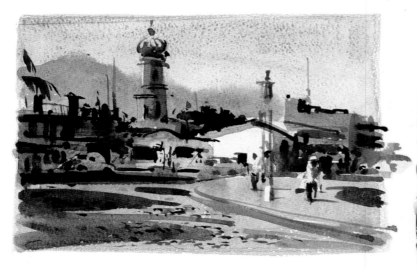

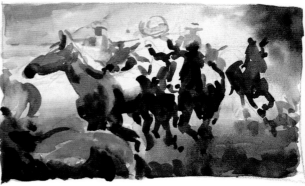

There's lots of opportunity to use calligraphy here. When I did a larger painting, I added some blue to the ground and a bit of warm color to the sky, making the whole painting more integrated and more pleasing.

This is a scene full of energy. Notice how the wet treatment of the background suggests dust stirred up by a pack of running horses.

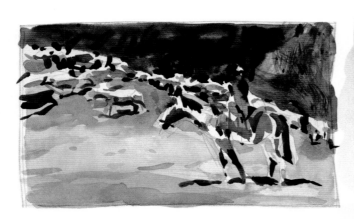

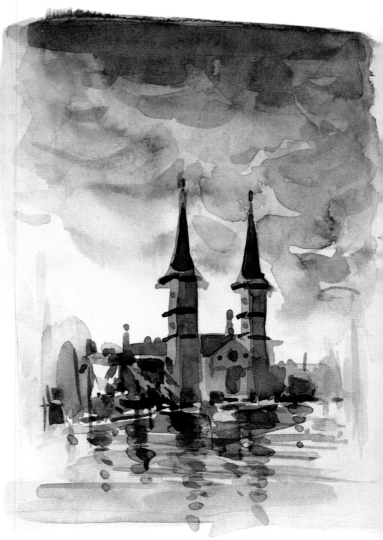

This is a good lesson to myself to paint broadly, swiftly, and not to belabor a painting. It's also a good example of opportunities to use rapid brushstrokes. The only change I might make would be to add a touch more definition to the sheep and the sheepherder on the horse.

Although I like the spontaneity of the brushwork in this sketch, variation in color and tone in the sky would add some drama to the scene.

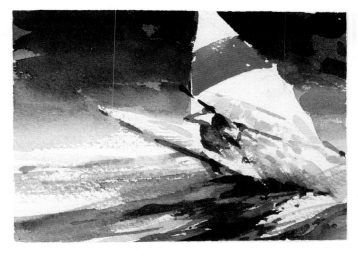

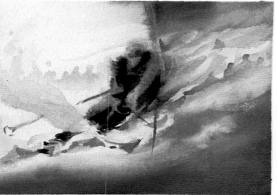

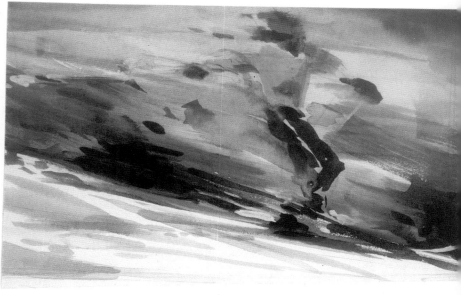

Motion is inherent in the subject matter here, but I've tried to enhance it with either diagonal compositions or head-on confrontations. I'm still surprised by the freshness of these sketches. The only thing I would do for a larger painting is to make them more abstract, and thus more intriguing.

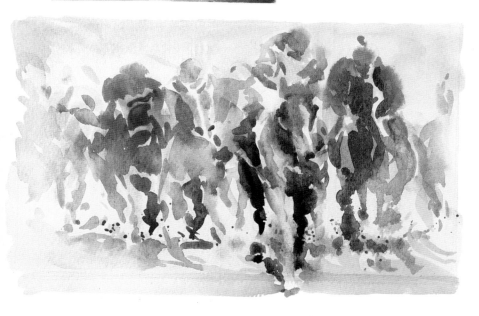

MOTION STEP BY STEP

Students often wonder how a painting is developed, from sketches through the initial painting stages to the completed work. For this section I have chosen six paintings, involving different kinds of motion, to show you several different approaches to the development of a painting. The first demonstration examines how to capture a characteristic movement in a sport—in this case, the swing of a golfer. In the second demonstration I indicate how you can convey both movement and mood at the racecourse on a rainy day. Speed and energy are the subjects of the third demonstration, which conveys movement somewhat more abstractly, through the handlebar of a bike. The fourth demonstration reveals the advantages of masking an area to create a spot of stability in the midst of movement. Then, in the fifth demonstration, I show how pigeons can enliven a cityscape, bringing a feeling of energy to the whole. Finally, I take an everyday subject—children playing in a field—and use the calligraphy of the brushstrokes to bring it to life.

Following a Golf Swing

Years ago I did some photography for a ballet recital. The dance instructor looked at the photos and picked out a number of them, with the comment: "Now, that's a peak moment of this step . . . and that's a peak moment of that sequence!" I realized that's also true of sports. Each sport has its own peak moment of movement, whether it's a pitch, a dive, a reach, a dash, a stride, a swash, or a swing. These moments are not necessarily the most beautiful ones, but they are culmination points, and every sports lover knows this and feels it.

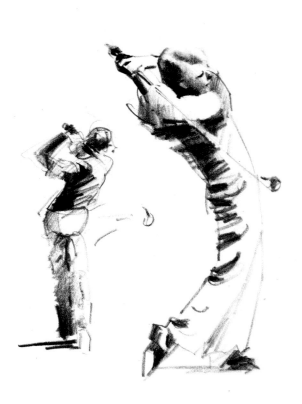

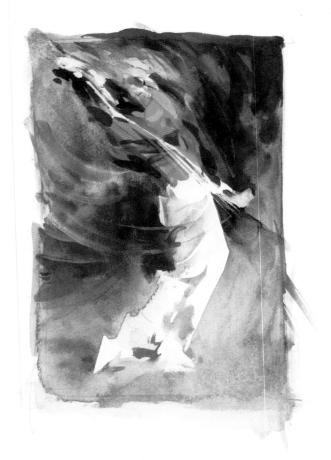

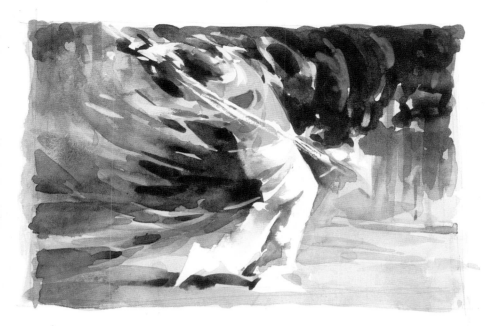

Sketches. Every step of a golf swing has its own energy, but the completion of a swing is a beautiful sight. I do some sketches just to know in my own mind the anatomy of the stance. Feeling comfortable with that, I do a small color sketch to explore color and composition. The vertical format feels like a natural one to use. I then do another small sketch in a horizontal format with different colors and exaggerate the stance, thinking it may add more energy to the picture. Wrong. The pose looks awkward, and the composition too predictable. After staring at it for a while, it occurs to me to make the upper left area white (see the second pencil sketch). Suddenly, the composition becomes more dynamic, more energetic. Also, I can combine the white area with brushstrokes for added movement. I quickly do another small color sketch, and it confirms my hunch.

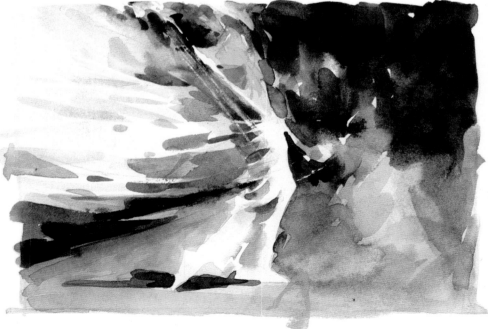

Step One. I always pencil lightly freehand, just enough to guide me in painting. In this case I make sure to draw the figure more carefully. Looking at the sketch, I know the painting has to be executed quickly, working wet-into-wet in most areas for soft edges. After evenly wetting the entire surface with a sponge, I take about a teaspoonful of glycerin and drop it evenly over the surface. With a damp sponge I gently mix the glycerin with the wet paper. I wait a bit, then paint in a light wash of moss green— mixing it here and there with a bit of raw sienna.

Step Two. Without waiting, I paint in the yellow shirt. With the same color, I put a few dabs right into the green. This is done so the yellow is not quite so isolated in the painting. Quickly, I paint a light burnt sienna into the face and hands area. For the hair, modeling of the face, hands, and a bit of the golf club, I use a more concentrated burnt sienna.

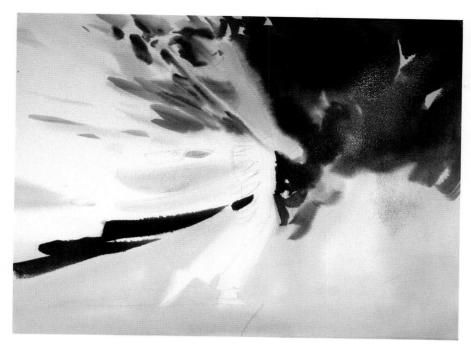

Step Three. I decide to go for the darkest area of the painting immediately with Hooker's green dark mixed with burnt umber. I try to paint around the yellow area and leave some white to show through so the dark mass will have some color and tonal relief. By now I can feel that the paper is less wet, or drier—whichever way you want to look at it. More by instinct than knowledge, I stroke in the light green next to the shirt, with the edges still soft but almost hard. I load the dark green again and stroke in the lower left with abandon.

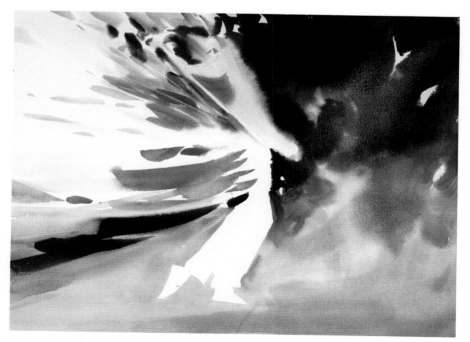

Step Four. With the edge of the dark green partially shielded by my own hand, I use a hair dryer to dry off the area around the legs. Quickly, I paint in the middle green tones around the legs, leaving hard edges, and blend the same tone with the dark green, which is still wet. The two tones blend softly. Switching over to a large round brush, I place deliberate brushstrokes next to the bend in the legs.

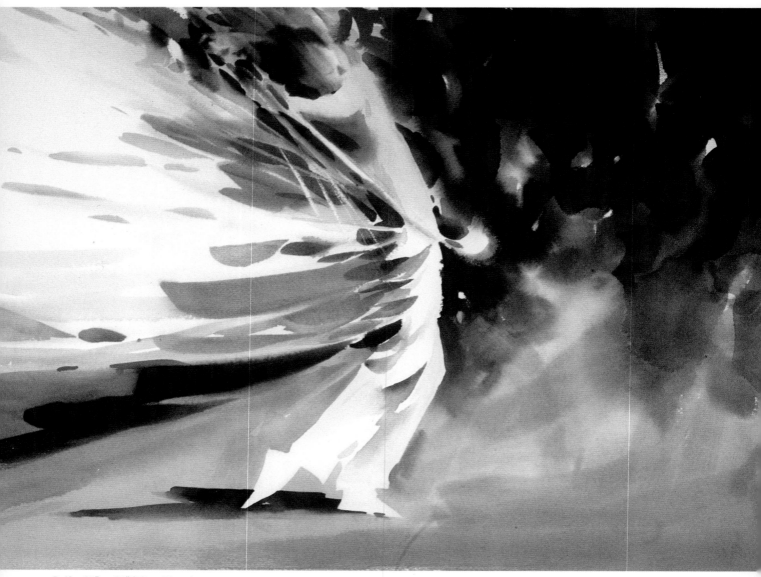

Golfer 21" × 28" (53 × 71 cm)

Step Five. I walk away from the painting for about half an hour. After the previous stage I feel good, so I take a break and have a glass of wine and just relax. This is a wonderful time. I've worked hard, with intensity. I have not goofed up. The end is in sight. I can now look at the painting with a fresh and critical eye.

The decision to make the painting somewhat abstract was made when I committed myself to the hard edges around the feet. What it needs now are accents and integration. Introducing folds inside the pants breaks up the flatness. I also add more green near the head and hands, as well as a few more dark strokes in the upper right. Other finishing touches include more definition around the golf club head, a few more brushstrokes in light brown, and a cast shadow to anchor the figure. I leave the scraping to the last. The painting could really do without it, but I think it adds interest to the eye and enhances the feeling of motion.

Depicting a Horse Race

If you've been to a horse race on a rainy day and stood at the finishing line, you're familiar with the sound and spectacle of the moment I try to capture in this painting. I can now understand how painters like Frederic Remington and Charles Russell could spend a lifetime painting horses—devoting a major portion of their work to this subject. Their paintings clearly reveal their love and knowledge of horses.

As I've already indicated, horses are a marvelous species to observe, draw, and paint. When I was a boy in China just starting to draw, I would painstakingly copy photographs and other artists' paintings of horses. Those awkward pencil drawings covered the corners of my textbooks until all the spaces were filled. One day my stern teacher scolded me for ruining my textbooks. The next day she gave me a stack of blank paper and walked away without a word. To this day I remember my astonishment.

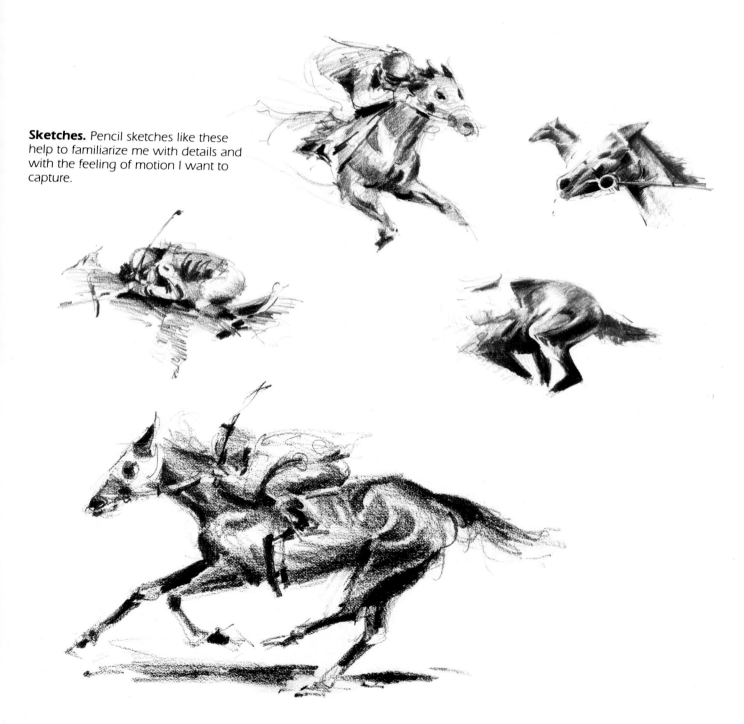

Sketches. Pencil sketches like these help to familiarize me with details and with the feeling of motion I want to capture.

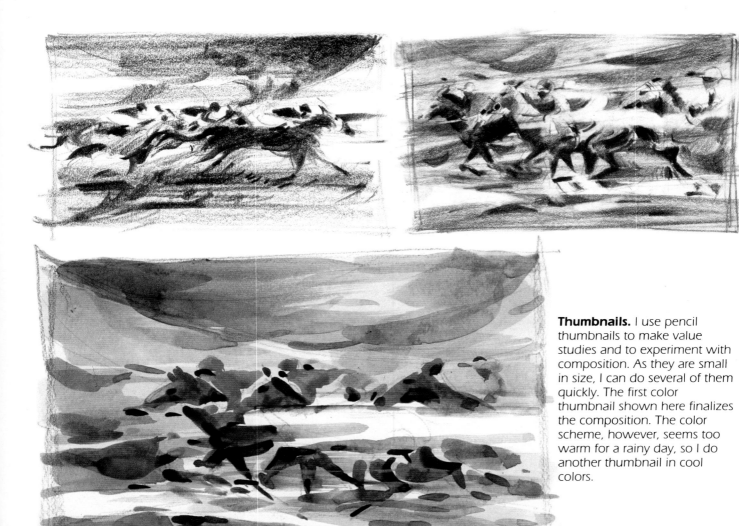

Thumbnails. I use pencil thumbnails to make value studies and to experiment with composition. As they are small in size, I can do several of them quickly. The first color thumbnail shown here finalizes the composition. The color scheme, however, seems too warm for a rainy day, so I do another thumbnail in cool colors.

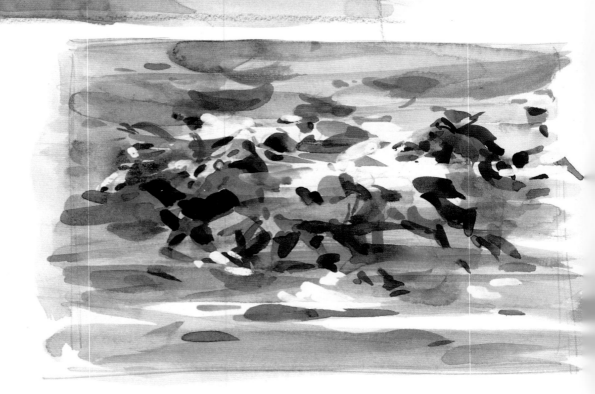

Step One. Again, I sketch the subject lightly in pencil, as a guide only. Although I intend to change to a cool color scheme, I deliberately lay in some yellow ochre in the beginning for a warm accent. This is done wet-into-wet. You can almost see the shine of the glycerin on the extreme right.

Step Two. Immediately I brush on a light wash of ultramarine blue using a 1¹/₂-inch flat brush. The surface is still wet, so the two colors bleed softly into each other.

Step Three. Without waiting, I quickly brush in some purple mixed from alizarin crimson and ultramarine blue. Continuing with my 1¹/₂-inch flat brush, I also brush in some blue by itself and some burnt sienna. I intend to introduce the dominant cool colors soon, but it's perfectly all right to reverse the color procedure. The important thing to remember is that the dominant color should be balanced by touches of some opposite color and something in between so the overall color effect is richer.

Step Four. Without breaking pace or changing brushes, I introduce the dominant color—Prussian blue—for the horses, using a lighter wash than I anticipate I'll want. After glancing at the color thumbnail to see the areas of white I want to leave, I quickly wipe those areas out with a damp sponge. I keep in mind the fact that the spaces I just wiped are now drier than the other areas.

Step Five. I now put some darker Prussian blue on the horses, as well as a darker red on the jockey, for more modeling. I decide to depict the flying mud with discernible brushstrokes to augment the feeling of movement and place these strokes around the legs of the horses. By now the paper is getting dry—you can tell by the brushstroke in front of the first horse, and some rather free and irregular brushstrokes on the last horse and the last jockey. This is a good example of creating movement with dancing brushstrokes.

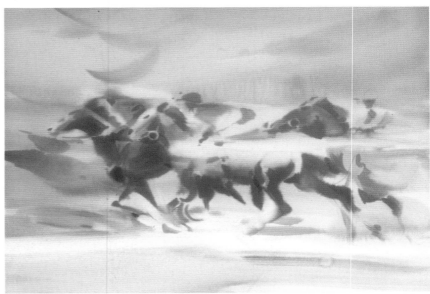

Step Six. Now, when the paper is almost completely dry, is a good time to put in strokes with harder edges. Note the curving sweep of the sky and dark accents around the feet of the horses. I also introduce a still darker blue into the horses and add sharper brushstrokes in front of the first horse. Washing in a light Prussian blue at the bottom of the painting brings out the white above it.

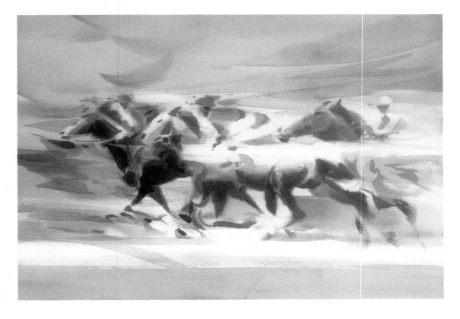

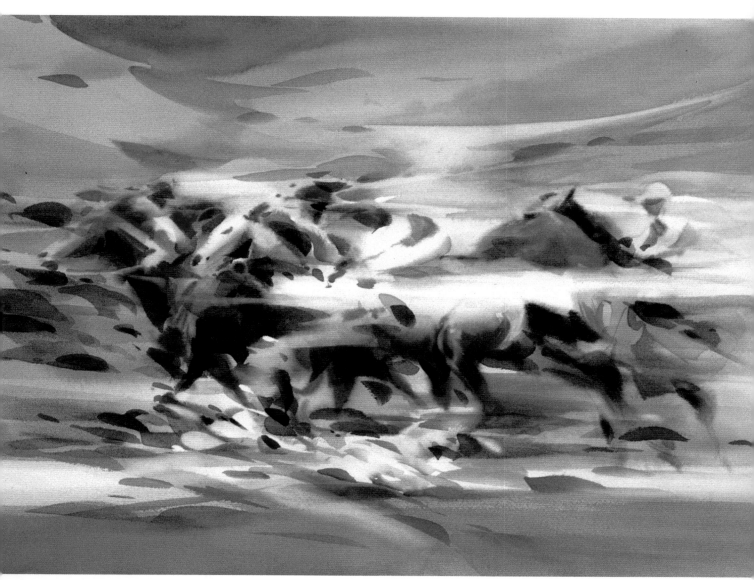

Horse Race in the Rain 21" × 28" (53 × 71 cm)

Step Seven. After step six I walk away from the painting, tired but feeling good. From step one to step six has been almost non-stop painting with only a short break between steps five and six. In total it has taken a little less than three hours—a fairly rapid pace for me.

Coming back to the painting after a good night's sleep, the first thing that strikes me is that the feeling of the flying mud and the wet pounding of the hoofs is not strong enough. I want more turbulence. The second thing is that the horses stand out too much against the background. Something has to be done to integrate the painting. I darken the sky and ground, leaving sharp edges to balance other sharp edges in the painting. More brushstrokes are added around the hoofs of the horses. I extend the white streak across the middle by lifting color off with clear water and a bristle brush and break up the even ground with some lifting and a few brushstrokes. While I am still doing that something inside of me tells me to stop, so I do.

Abstracting Speed

This painting has given me a lot of pleasure, especially in showing it to different people. Some of them couldn't immediately figure out what the subject was. But some did. I intend to do more paintings like this—it's fun for me and fun for the viewers. For me it's an abstract with a purpose. It makes the viewer work a little harder, with perhaps a greater sense of satisfaction when he or she finally discovers what the subject is.

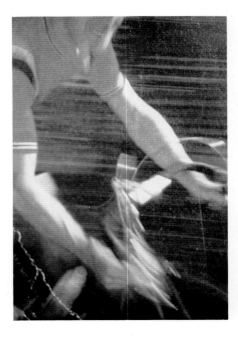

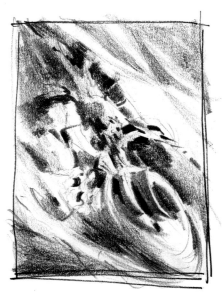

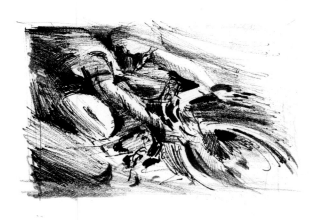

Photo and Sketches. My idea for this painting begins with a photo from a magazine Something about the handlebar and the hand intrigues me. As I often do, I begin with pencil sketches to explore the format, shapes, composition, and potential for motion. I finally settle on a horizontal format with a diagonal feeling of motion. The color thumbnail gives me a good idea of both the color scheme and the degree of abstraction I want. I should mention that although this method of doing a painting works for me, that doesn't mean it's right for everyone. I have seen some wonderful paintings done with little or no preplanning, where the painting is created as it's being painted. So experiment with this method, but don't take it as gospel.

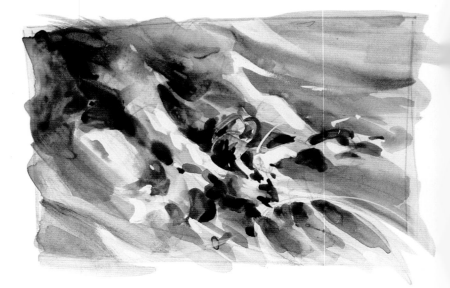

Step One. After penciling in the main forms, I wet the entire surface with water and a bit more glycerin than usual. I want the completed picture to have an overall softness, with a minimum of hard edges. It helps to make the subject less defined. It also means speed will be essential to all phases of the painting process. With a flat brush I broadly stroke in the main colors in lighter tones. I try to remind myself to vary the color even though the painting will have a monochromatic look when it's finished.

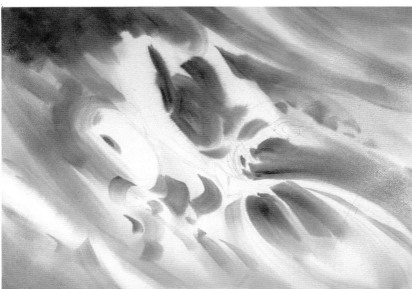

Step Two. Now, with burnt sienna straight out of the tube, and with a loaded flat 1½-inch brush I take a deep breath, muster all the concentration I can, and plunge in. Most Oriental paintings are done *alla prima* (all at once)—the artist aims at achieving final result in one sitting, rather than in stages. That thought races through my mind. I wish I had three brushes and four hands so I could finish the painting in one swoop. Can I do it? Not quite.

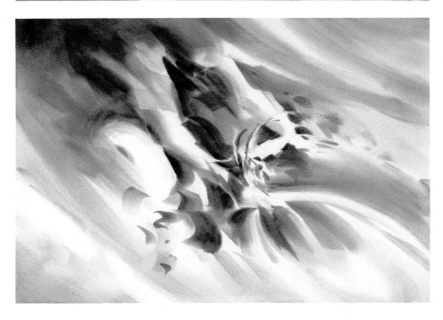

Step Three. Disappointed but undaunted, and without missing a beat, I reload my brush—this time with more burnt umber. I also load another brush with some pale alizarin crimson. Keeping the strokes few and bold, I plunge in again. Then I rest a bit. I'm sure you have experienced a similar exhilaration. This is the joy of painting felt by all artists in all ages.

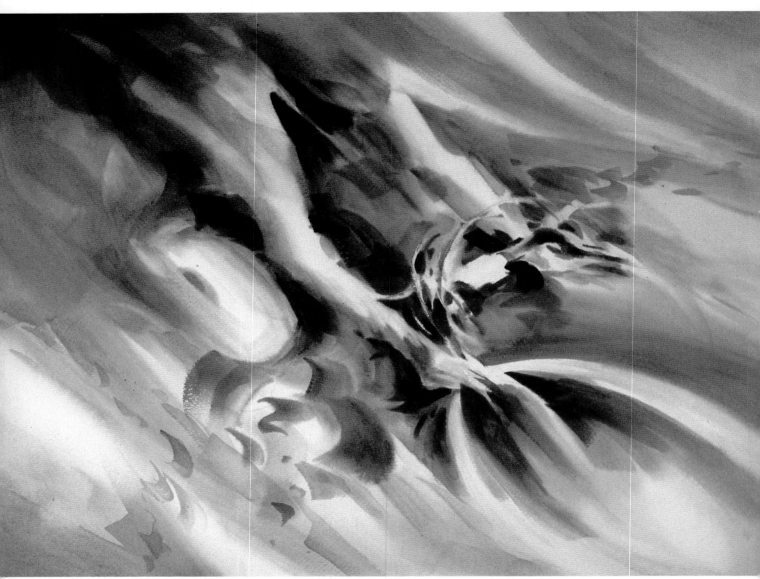

Handlebar *21″ × 28″ (53 × 71 cm)*

Step Four. *While the paper is still moist, I quickly analyze the painting to make my last move. The diagonal sweep is strong, but could be stronger, so I brush in more darks. In a flash I think how nice it would be to counter the strong diagonal with some small, lilting brushstrokes in the opposite direction. With a 1-inch chisel-edged brush I quickly "dance" in the strokes. What else? Why not a touch of cerulean? In it goes—on the left wrist and the right upper arm, plus two dabs on the left side of the painting. I really must stop before I ruin it. Total painting time: two and a half hours.*

Portraying a Sailing Race

Every year on Lake Minnetonka, near Minneapolis, a sailing race is held for the local sailing enthusiasts. I was invited to one of the races and was knocked nearly unconscious by a loose boom. Fortunately, I recovered enough to take a few photographs on that day.

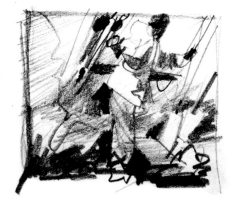

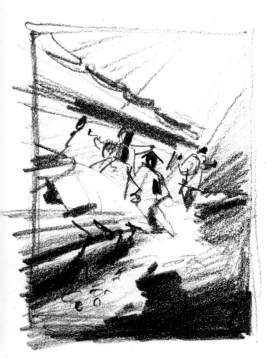

Sketches. From the photographs I make four pencil sketches. Although I think either the vertical or the horizontal format would work as a painting, I pick the horizontal one for more motion. Then, when I finish the color thumbnail (4 × 6 inches, 10 × 15 cm), I like it so much I wish I had a machine that would just blow up the sketch. Anyway the thumbnail proves a real roadmap to doing the finished painting.

Step One. This is one of the few times when I feel it's necessary to use masking. It would be almost impossible to paint around the water splashes, especially when the color behind changes in value. In my pencil drawing I carefully outline the waterdrops so I can apply the masking fluid correctly. I use rubber cement and work with a small, cheap brush, as you have to clean the brush with a solvent, which would ruin an expensive sable. A word of advice: all too often masking is so conspicuous that it spoils the painting. If you must mask an area, do it with a fine, round brush, and vary the size and shapes. Here, after masking the splash area, I wet the paper—but without glycerine because there is no need to prolong the wetness. I use Prussian blue to brush in the sky and water. Using the same brush I mix in a little burnt sienna for the boat.

Step Two. I paint in the figures using burnt sienna for the faces, yellow and orange for the slickers. The only change from the color thumbnail is that I make the red slicker white. I feel the whole painting is already quite colorful, so it doesn't need another splash of bright color. By now I'm no longer looking at photographs. Instead, I refer to the figures in the sketches. Why? It's easy to get caught up in details if you keep painting from photographs. Working from sketches forces you to look at the painting as a whole so you can tighten or loosen the areas of *your* choosing. I'm already modeling the figures as I paint. And simultaneously I bring more darks to the water, the boat, and the sail. If you can, try to keep the entire painting at the same degree of finish—so, again, you look at the picture as a whole.

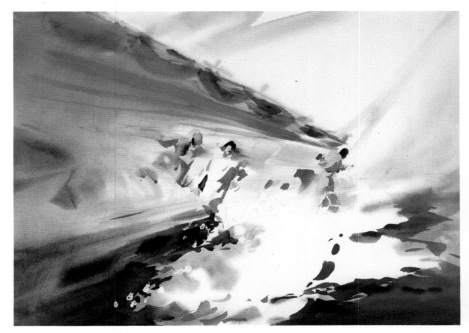

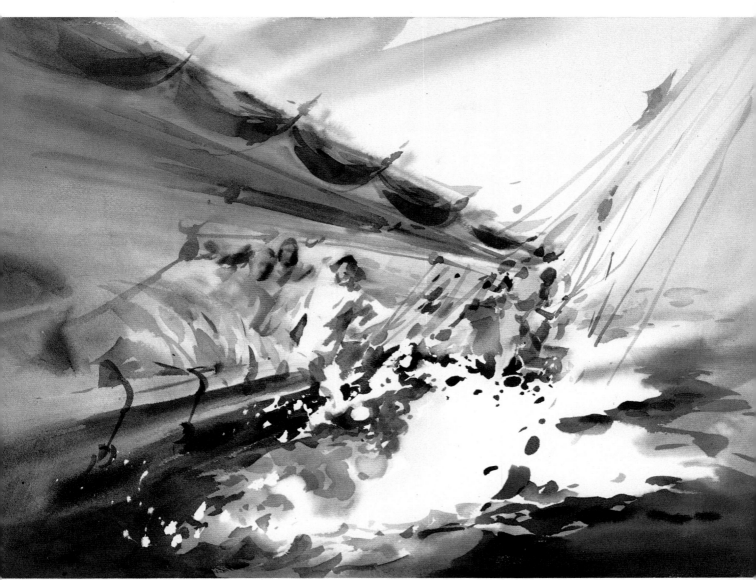

The Burton Cup Race 21" × 28" (53 × 71 cm)

Step Three. I add modeling to the figures and details to the boat and sail. By now the paper is completely dry. I add middle tones to the water for more depth. Then I put the darkest color behind the water splash, which is still masked. At this point I take a break to give the paint around the splash a thorough drying. Usually after a lengthy period of painting I like to leave the studio for a change of scenery. When I come back I feel refreshed and ready to put the icing on the cake. First I dry the masked area with a hair dryer just to make sure it's thoroughly dry so there will be no smearing. After lifting the masking, I scrape around the white area with an X-acto knife to get rid of any obvious signs of masking. At the very end I add the rope lines with some dark squiggles in between for accents and focus.

Focusing on Birds in Motion

The idea of painting a flock of birds in motion has always been fascinating and challenging to me. But to use birds as the main subject poses some difficult problems in terms of both composing and defining the birds. One way to define the birds is to place them against a dark background. In the past, however, I've not been very successful in finding a dark area and composing it in an interesting way. This time I find what I need—in a photo in the Sunday paper showing seagulls against a cargo ship in Duluth, Minnesota.

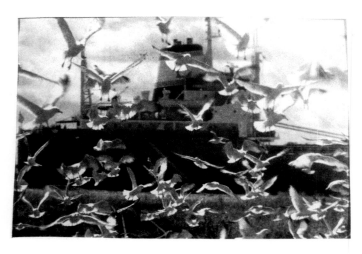
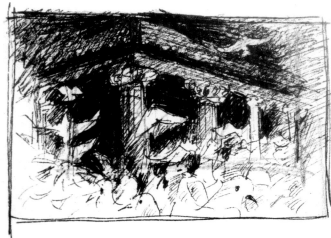

Initial Thumbnails. I'm not sure the ship in the background is right, so I arrange the birds in front of a made-up building. It looks better. To convince myself, I do some color thumbnails with the birds against the building and against the ship.

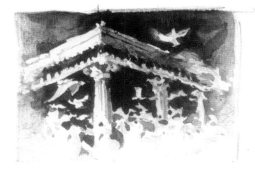
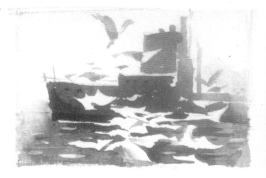
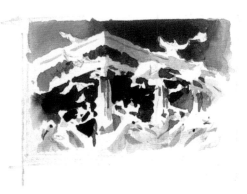
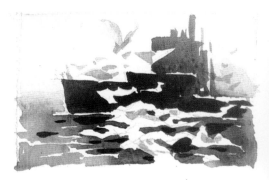

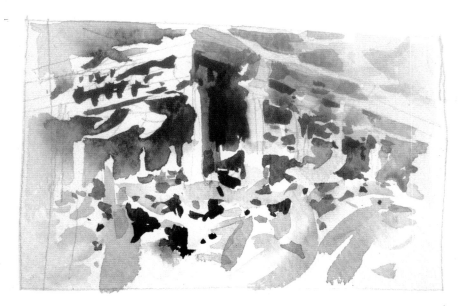

feeding the pigeons

Revised Thumbnails. Convinced the building is the right background I do another sketch to show more birds. Not satisfied with the composition, I go back to pencil and recompose the scene in a vertical format. Suddenly, everything pulls together, with a more focused dark area and some interesting possibilities to play with the birds in motion. At first I think someone should perhaps be feeding the birds, but I discard that idea as I begin to sketch it on paper.

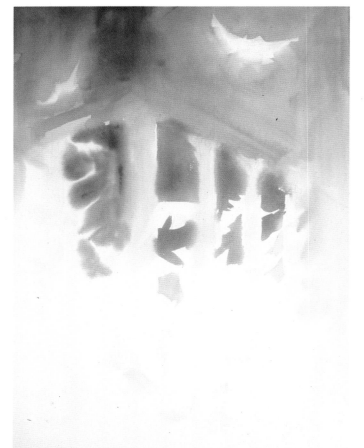

Step One. After penciling in some minimal guidelines, I wet the surface only in the area where I want soft edges (I anticipate the need for some hard edges around the birds). I then put down a light burnt umber wash with a touch of Prussian blue wet-into-wet for interest. I randomly lay in the same light blue in the "bird area" below the building.

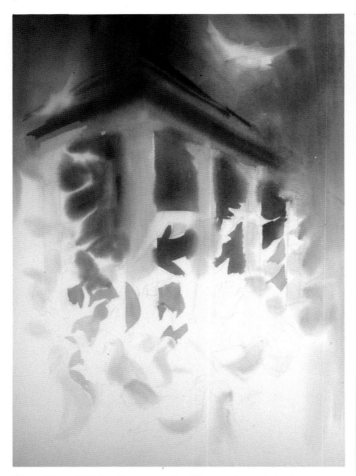 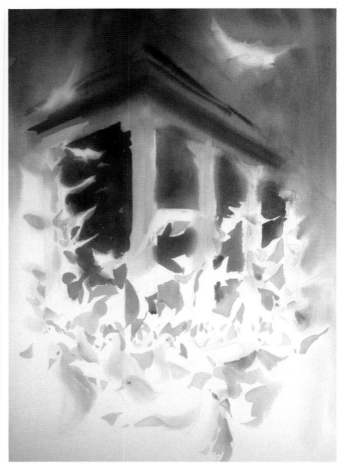

Step Two. While the paper is still wet, I wash in the Greek columns with some light burnt sienna. Next I mix burnt sienna with Prussian blue to deepen the color in this area. After adding more blue to the upper right area, I brush some light blue into the birds and stroke a bit of brown around the column closest to the viewer. For the angular roof lines, I work wet-into-wet to determine how dark to paint the darkest area. I now pause to let the painting dry.

Step Three. I begin this step with two things in mind. First, I intend to determine the darkest area of the painting. Look at the shadow area on the left side of the building. Without that dark in place, it would be hard to paint the middle tones. Second, I intend to use my brushstrokes to depict motion and to define the birds. As I work, I try to keep the entire painting more or less at the same stage of completion. In that way I avoid the trap or temptation of overworking a particular area.

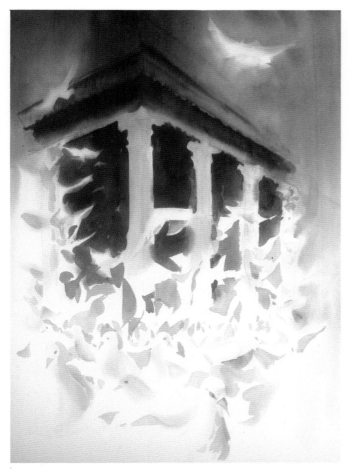

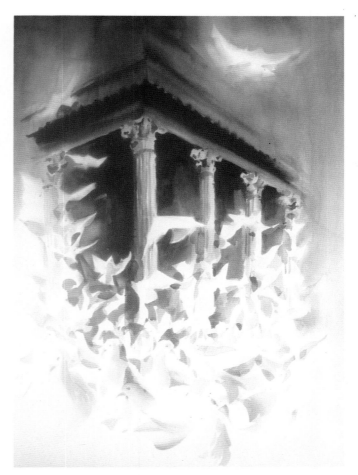

Step Four. Now I complete the darkest areas between the columns and define the roof lines with a bit more detail, adding depth. At this point I realize the darkest area lacks depth.

Step Five. Immediately I lift the dark brown area with a bit of clear water and a bristle brush. I dislike doing this, but sometimes I don't have any choice. I then give some further definition to the columns and add a few more brushstrokes—darker but smaller—to the birds. After a hard look at the painting, I walk away from it for the day.

Step Six. After a day I can look at the last step with a more critical eye. The painting looks top-heavy. I must now bring more darks down into the birds, without losing the feeling of flight and flutter. With great care I go over the birds with darker shades of blue and brown, maintaining the same hard and soft edges. It's a tedious process, but it darkens the area without making it look overworked.

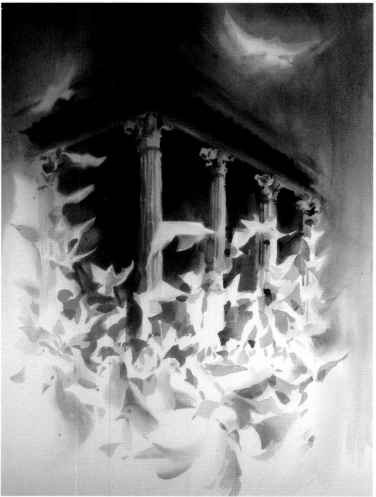

Pigeons 28″ × 21″ (71 × 53 cm)

Small Version. Some days later I redo the painting in a smaller size. I do this to see how it would look if I don't have to worry about stopping to photograph at different stages. Which is the better painting? You be the judge.

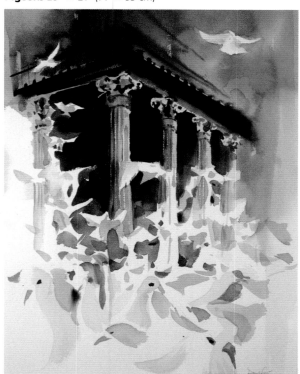

Pigeons 22″ × 16″ (56 × 41 cm)

Working with a Group of Figures

Occasionally, the urge to paint figures overtakes me and I just have to do it. Showing many figures together, as I do in this demonstration, is a good drawing exercise in terms of scale, proportion, and anatomy. With the scene shown here, I was also interested in lighting and the use of lively brushstrokes.

As the light is coming from behind, the figures are rimmed with light. This has a warm and pleasant effect, and it tends to push the figures forward.

As you can see in the final painting, there is hardly any modeling within the figures. The flesh tones and shadows are applied in broad strokes with hard edges. In this way I maintain the liquid "feel" of watercolor and keep a fresh, unlabored look.

An interesting way of looking at this painting is to forget, for a moment, that these are children and look only at the brushstrokes forming the figures. The whole takes on a quality of calligraphy as the eye moves from one stroke to the next.

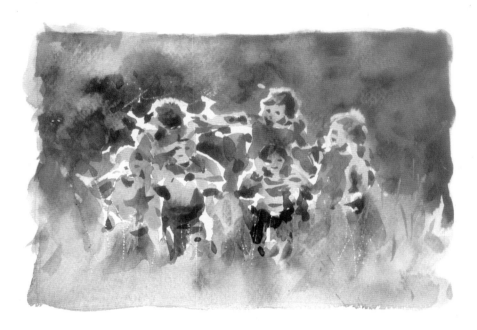

Thumbnail. With my color thumbnail I quickly determine the look of the backlit color scheme. Although the figures are not accurately drawn, this sketch provides a definite clue as to how I should go about the painting.

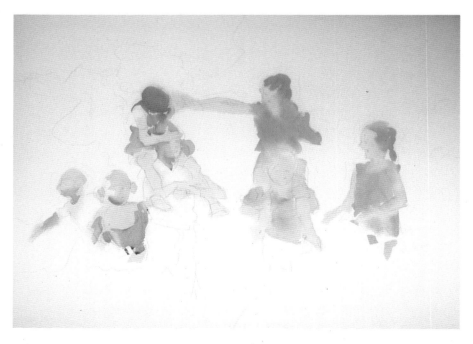

Step One. With my initial penciling-in, I pay more attention to the accurate drawing of the figures. To keep a rimmed light around the figures, I don't want to let the background touch them. Therefore, instead of wetting the paper first (as I normally do), I start by painting the figures wet-into-dry. The light earthtones run into one another here and there, giving an overall color tone, but they are different enough to define the basic figure shapes.

Step Two. By not wetting the paper first I can maintain a fairly crisp edge around the figures. I use primarily Hooker's green for the background. With a 1-inch flat brush I paint the darkest green around the figures; then I dilute the green with more water and paint in the foreground. By mixing Hooker's green with burnt umber I get the mossy green I want for the top and quickly put it in. Then I add Prussian blue to the pants of the two boys. I let the color run into the background to create textural interest. While waiting for the background to dry, I brush a few more flesh tones into the figures to keep this stage of the painting more uniform.

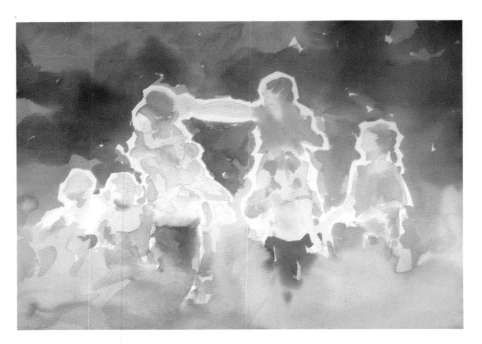

Step Three. When you paint a dry surface, the washes tend to dry faster. As I begin this step, the surface is almost completely dry. I can now concentrate on the brushwork in the figures. I think this is a good example of letting brushstrokes simultaneously define the figures and express motion. The strokes are rapidly put down and some of them interconnect with, I hope, authority. As the figures become dark, I also darken the background around them with visible strokes.

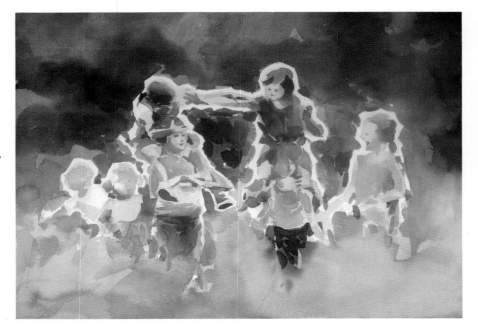

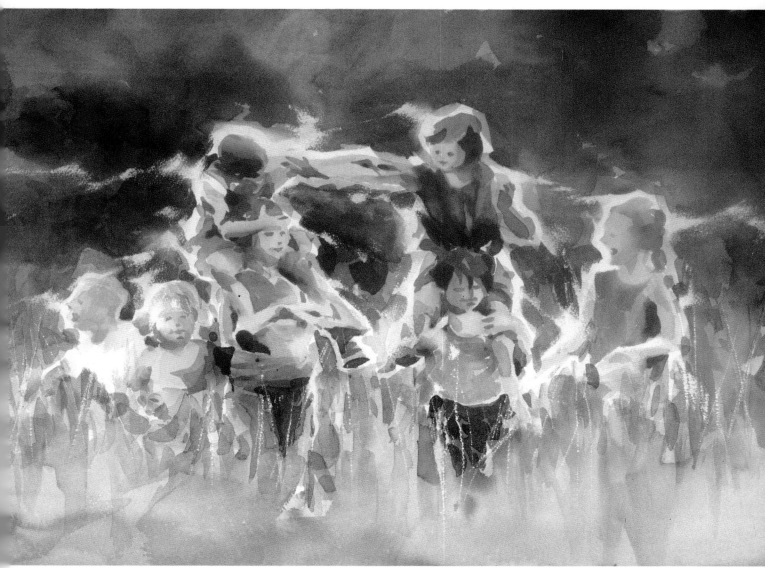

Children in the Field 21″ × 28″ (53 × 71 cm)

Step Four. Now I brush in the tall grass with vertical strokes and add some scratches with an X-acto knife. I also add a few more dark strokes to the figures. Looking at the painting, I ask myself what else I can do to create motion and give it a livelier feeling. It occurs to me that the line joined by the two arms could be extended across the painting in an irregular way, to break up the static feeling. I do this by scraping with a Boy Scout knife. I then scrape some more around the figures to break up the silhouette feeling even more. All of a sudden the painting is more dynamic. For the finishing touch, I place a tint of pale yellow into the scraped-away area, giving the light a warm glow.

PUTTING IT TOGETHER

Watercolor is the only medium that offers the look of "careful carelessness" and "planned accidents." You can almost smell the freshness and feel the energy. Yet I doubt very much that one can achieve this kind of spontaneity consistently without some method of planning and a good mastery of the medium.

What I have shown you are the elements of my approach to watercolor. By developing sound drawing skills and planning your paintings in small thumbnail sketches, you will have better control and will be able to let "happy accidents" happen.

Einstein said, "Genius is 10 percent inspiration and 90 percent perspiration." It's true of watercolor. You may stumble on a delightful and spectacular result 10 percent of the time, but you are more likely to achieve this through a lot of practice.

If you are serious about painting, you will be interested in what other painters are doing or have done, in the past. That's how we all got started, how we are inspired and influenced. Artists are instinctive learners. We can learn by just looking at a good painting. I hope that the following selection of paintings will inspire you, just as I have been inspired by other artists' paintings.

My normal habit is to do a lot of pencil drawings first. It's a warmup exercise—a time to get in the mood, or spirit, of the painting. It's also a time to think and experiment with composition.

With my first color thumbnail, I felt comfortable with the motion and composition, but not totally happy with the color scheme. I wanted it to pop. Some days later I accidentally came upon a color combination in a magazine that really popped for me—black and cerulean blue. That was it. I also decided the motion should be carried by some discernible brushstrokes.

The black and blue combination was strong enough for me to disregard a more normal color background. But a flat black was a little too much, so I mixed in some Hooker's green. This also helped to integrate the green foreground.

For the brushstrokes, I used a flat 1¹/₂-inch and a 1-inch brush. The strokes repeat in a half-moon shape, but vary in size, color, and direction throughout the middle section of the painting. Although the attitude of the figures carries the main feeling of motion, I think this is enhanced by the brushstrokes and a little streaking around the two top figures.

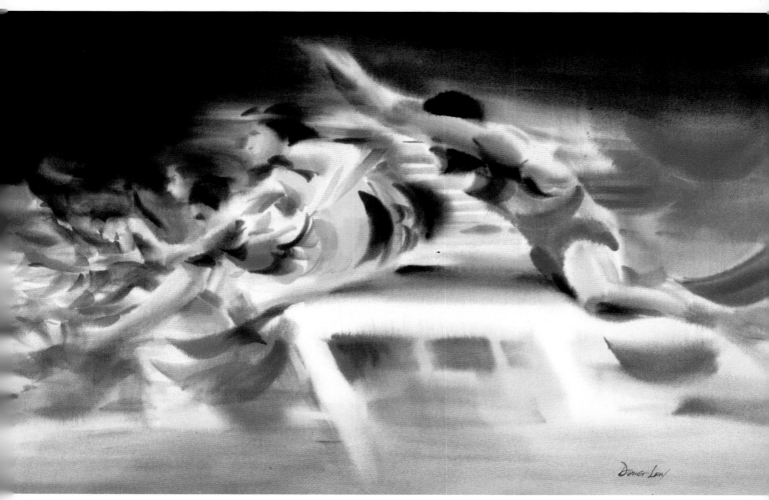

Hurdlers 23" × 35" (58 × 89 cm), collection of KARE Broadcasting

Creating an Impression of Speed

This might as well be an abstract painting. The strong feeling of speed and motion is probably what you notice first. From the start, I was out to get a feeling of power, energy, and speed. I thought my color sketch captured it very well.

I decided not to use the streaking technique in this instance and instead brushed the moving figure in. Details were deliberately left out to emphasize the gesture and the sweep of the movement. Most important, I worked at letting the brushstrokes be as apparent as possible. They have a way of generating energy by themselves.

Whether by accident or by design, I think the best part of the painting is the foreground. The calligraphy is free and easy. If you squint your eyes, you should feel the surge of the skier rushing toward you. And the same calligraphy should suggest the trail of the snow made by the previous skier.

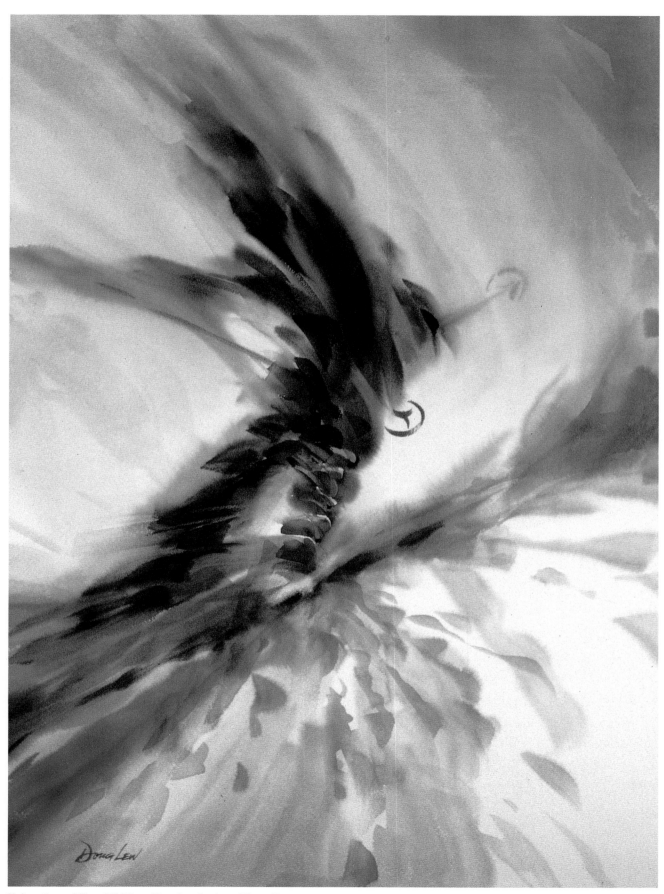

Slalom Racer 28" × 21" (71 × 53 cm), collection of Xerox Computer

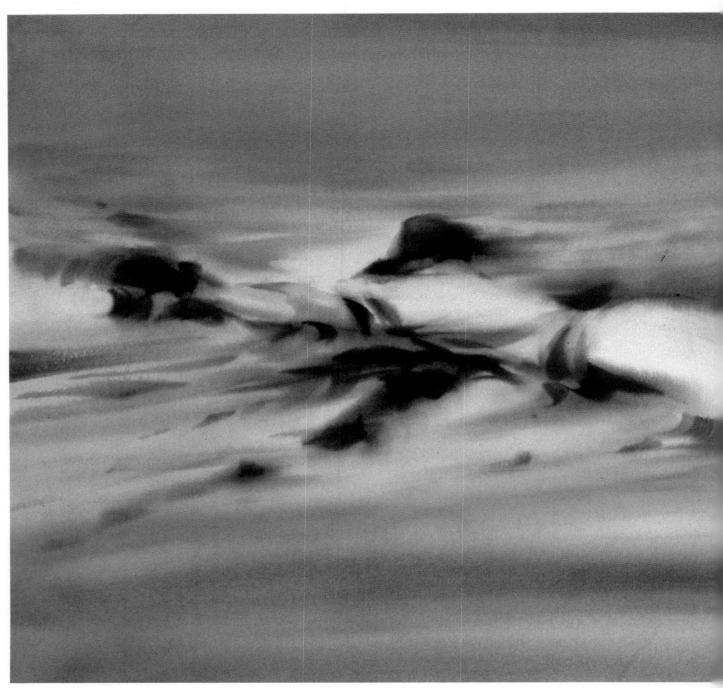

The Catch 20″ × 28″ (41 × 71 cm), collection of Xerox

A friend who saw this painting said, "I normally don't like sports painting, but I like this one." I asked her why. She said she didn't know. I venture to guess it's because she's drawn to the gracefulness of the figure, the abstract quality, and the color. These are elements of a painting that exist in spite of subject matter. Look at the detail. Sure, it's an arm with a glove reaching for a speeding ball. It's also a pleasing combination of brushstrokes, done with a harmony of colors.

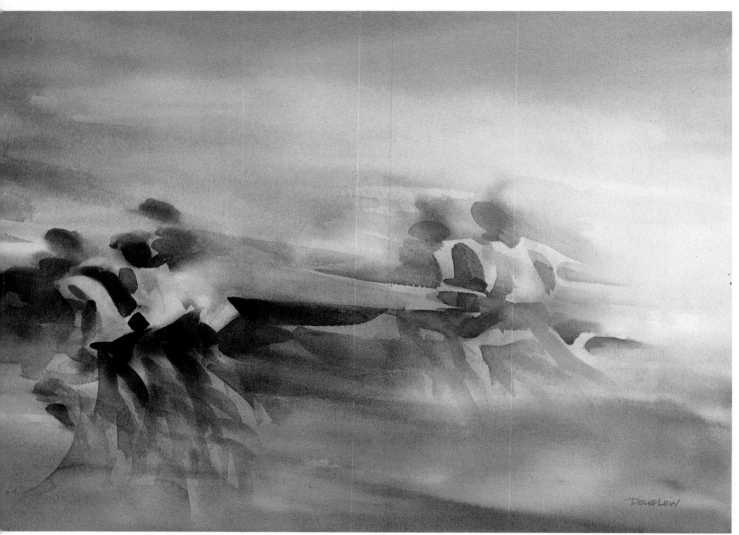

Runners 22" × 28" (56 × 71 cm)

In this painting, motion was suggested not so much by blurs as by abstraction and brushwork. Although there are many sharp edges, I took care to soften them in some areas, establishing an overall harmony of shapes. Making some of the hard brushstrokes close in value to the background gave an illusion of softness and blending. This is a lesson I learned from the French Impressionists. You might see this painting as Impressionism revisited with my own little twist—motion.

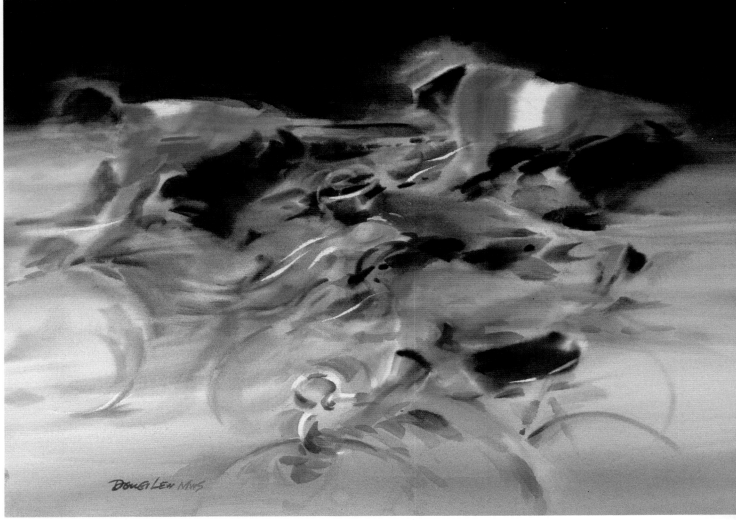

The Colorful Bikers 21" × 28" (53 × 71 cm), private collection

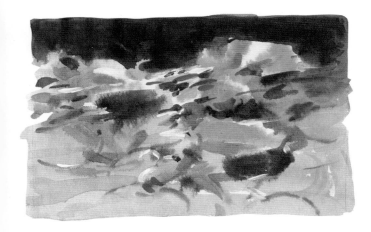

One of the games I play with myself is to see if I can paint a recognizable subject without showing the recognizable features of that subject—for instance, a horserace without any horses or a golf game without any golfers. In this case, my goal was bikers without bikes—or almost. I'm afraid that without a few lines to suggest wheels it might be difficult to figure out what was going on. Of course, whether it's necessary to know that or not is a whole different matter.

I made sure the surface was wet long enough to do 80 percent of the painting, which meant executing it rather quickly. For the most part I used the streaking technique horizontally to convey motion. Later, I defined the heads and arms, strengthening the drawing. Finally, the white highlights were scratched out with an X-acto knife. They add a fluttering effect to the motion.

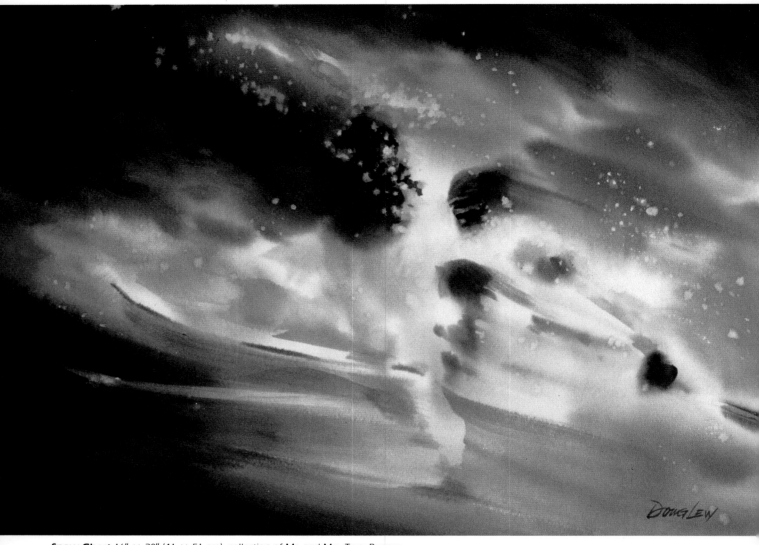

Snow Ghost 16″ × 20″ (41 × 51 cm), collection of Mr. and Mrs. Terry Bremer

The spraying of fresh powder by a speeding skier is a fascinating sight. I used my camera to capture this moment on a bright, sunny day. Although I bracketed the exposure to anticipate the high contrast, I was disappointed with the results. The spray of snow didn't have the middle tones I saw with my own eyes. The painting then made up for that disappointment.

I used the drawing to help establish the composition and to arrive at a better arrangement of lights and darks than the photograph showed. Once that was determined I was able to concentrate on varying the soft middle tones in the light area. Later in the painting I used salt to pick white spots out of the background—a technique I have used only a few times.

When I finished, I wasn't sure about bringing this painting to the gallery. I thought it was too abstract. So I put it aside. But when my friend Terry Bremer visited my studio, he picked it out and said, "I like this skier. I want to buy it." So there—you never know.

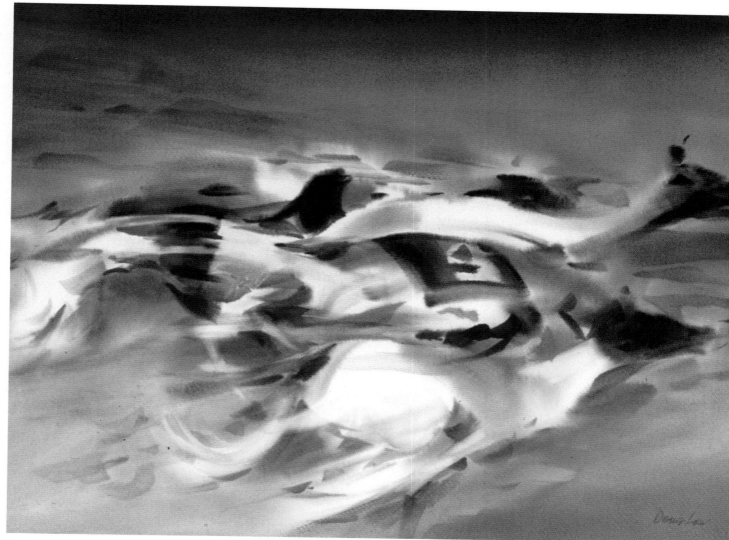

The Greyhounds 16" × 20" (41 × 51 cm), courtesy of C. G. Rein Galleries, Minneapolis

This painting was done in my studio in the middle of our long Minnesota winter. Outside the landscape was black, white, and gray. The yearning for spring, warmth, and color can be strong.

For this painting, I used the wet-into-wet technique described on page 39. I wet the entire surface with a bit of glycerin to prolong the drying process, so I was able to finish the painting with the paper still moist. This technique allowed me to keep the shapes of the dogs very soft, blending them into the background. The only discernible brushwork is around the dogs, particularly around the legs of the bottom dog. These brushstrokes emphasize the movement of the legs. And, I hope, they leave my own personal hallmark.

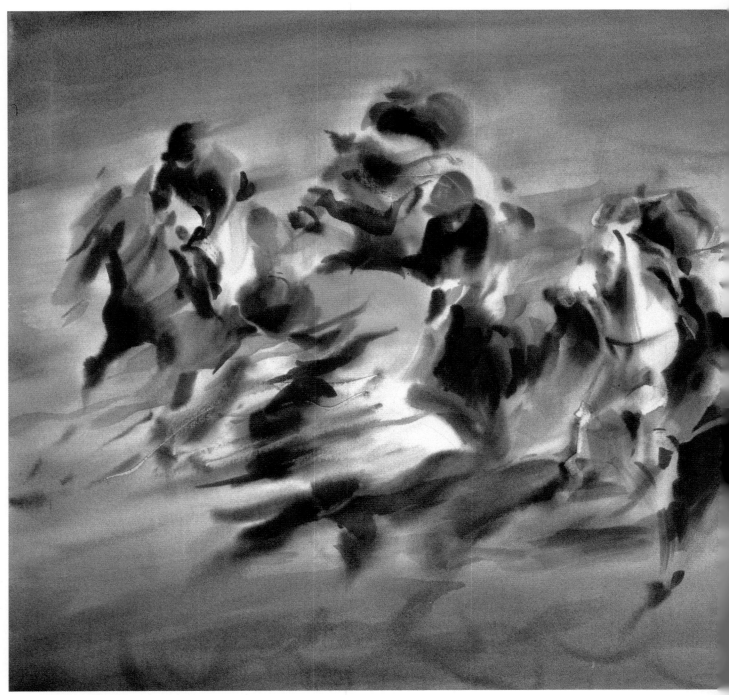

Gray Day at the Downs 22″ × 28″ (56 × 71 cm), collection of KARE Broadcasting

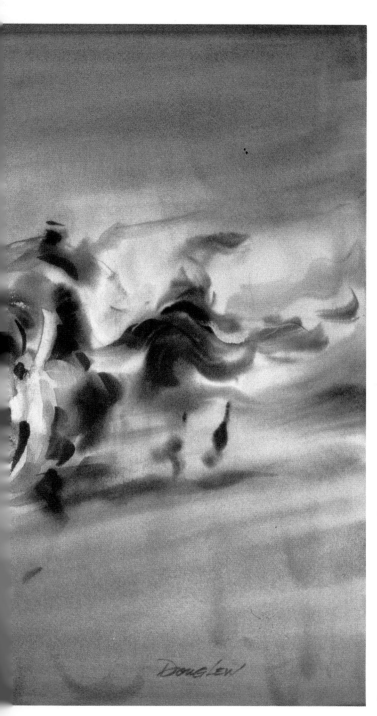

My main goal in this painting was to keep the horses moving fast. I make the blurs curving rather than straight, so brushstrokes could be used to simultaneously suggest the speed and the shapes of the horses.

With this kind of impressionistic rendition, if you make one thing a little clearer, the viewer can usually fill in the rest. In this case the horseman at the extreme left is fairly recognizable. So is the white horse in the middle and the one next to it, to a lesser degree. The rest is more or less a blur, especially the rider at the extreme right. I like that one.

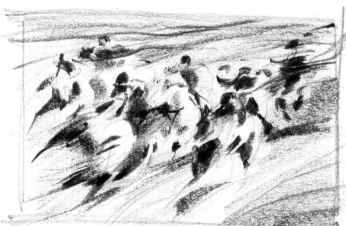

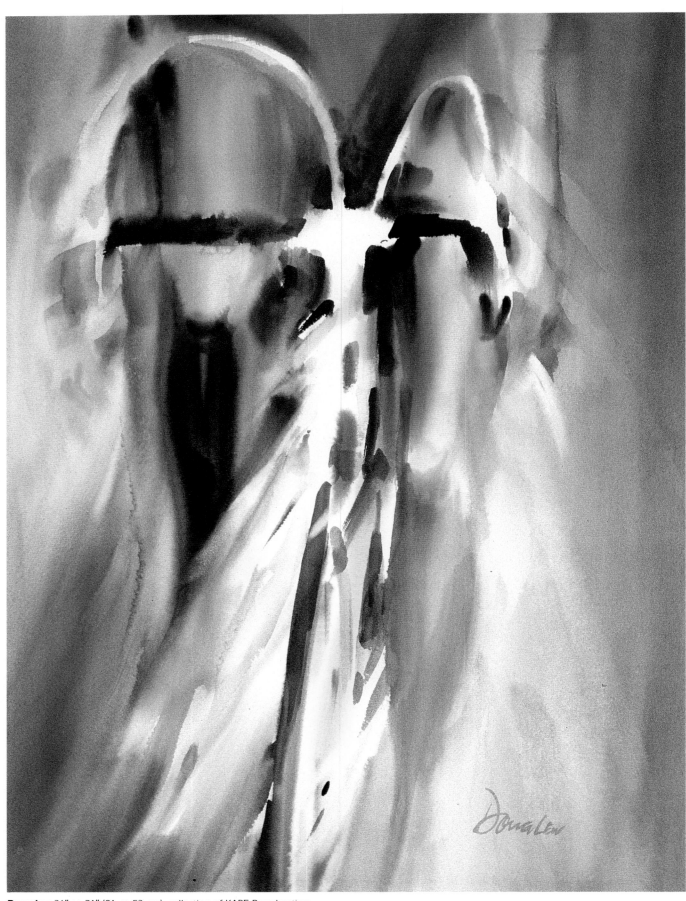

Pumping 36" × 21" (91 × 53 cm), collection of KARE Broadcasting

Because of the large-size subject and the large-size paper, which I had to lay flat, I wished I were ten feet tall with brushes two feet long when I worked on the painting entitled *Pumping*. What I did was to lay the stretched paper flat on two cardboard boxes about knee-high. This at least gave me some distance.

By placing the lightest and the darkest areas fairly close together, I created a focal point around the middle of the handlebar. As with many of my other paintings, I tried to keep the surface wet almost to the end and avoided sharp edges as much as I could. I am still surprised when I see this painting from a distance how sharp and clear the subject is.

Notice the hands and how the forms are barely indicated. In this I was influenced by Sargent—one of my favorite painters.

When I did the painting *Pumping*, I thought right away of doing a back view of a biker. This time I wanted it more abstract. I started sketching with a half-dried felt-tip marker, going after shapes primarily. This drawing, however, became confusing for me so I switched to pencil to get a better idea of values.

Notice the ambiguity of the feet in the final painting *Breaking Away*. Not painting in the shapes of the feet gives a sense of the feet moving and pedaling. Keeping the spokes of the wheel soft also gives a feeling of the wheel turning.

I think I succeeded in making this painting more abstract. It's one painting you might hang upside down, just for the fun of it.

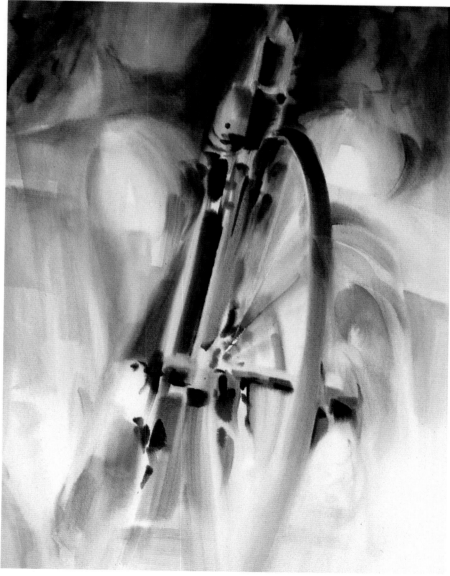

Breaking Away
28" × 22" (71 × 56 cm)
courtesy of C. G. Rein Galleries, Minneapolis

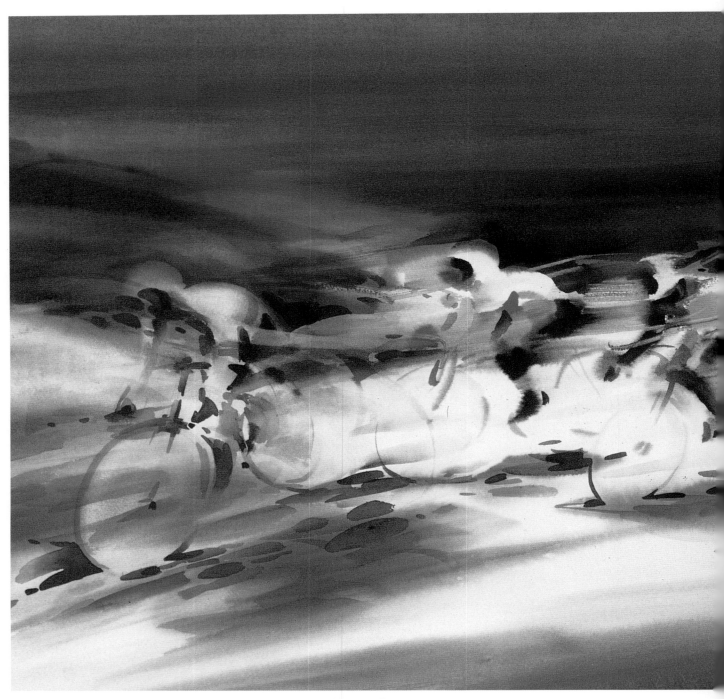

Joy of Biking 22" × 28" (56 × 71 cm), courtesy of C. G. Rein Galleries, Minneapolis

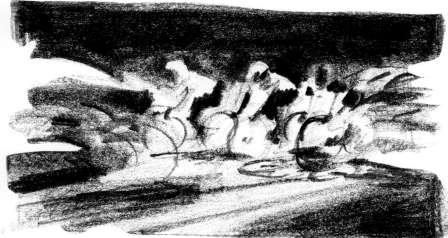

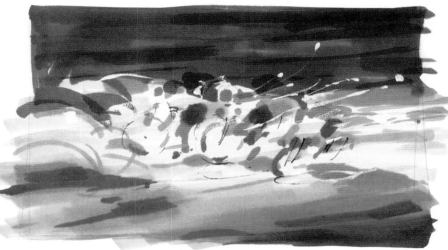

When I did the pencil rough, I was fairly happy about the composition, but I wasn't sure whether a fourth rider should be included. Then, when I did the color thumbnail, I thought about showing just the back side of a rider, roughly indicated by the two brown shapes in front of the first rider. With that in mind, I started the final painting.

I didn't want to use any opaque white so I was very careful about the area on the right, above the last rider. These streaking, white lines are crucial to showing speed and motion. The feeling of motion is further enhanced by blurs, streaks connecting the riders, and the large white area broken up by soft shades of blue in the middle.

I was almost done with the painting when I decided on the spur of the moment to complete the fourth rider. With clear water and a bristle brush, I lifted the figure out of the background. Who says you can't correct watercolor?

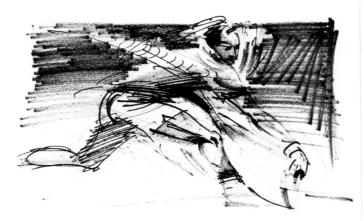

Tennis is one of the few sports in which there is no body contact. I like that. It's a game of mental concentration and psychology. I like that, too. It's a game in which there is virtually no ungraceful movement. I love it!

In the sketch I concentrated on the action of the figure, the correct stance of the right leg, and the twist of the wrist. I didn't, however, deal with the background or the composition.

In the painting I had to decide whether to treat the crowd realistically or use it as a mass in the composition. By making it dark, I let the figure stand out. Notice how the blues and purples in the crowd repeat colors in the figure, connecting the two elements.

Overall, the key to motion is making everything rather soft since the main shapes are so large and contrasty. The blur of the player's white shirt softens the left side of the painting, thereby putting more emphasis on the outstretched wrist. Even though the angle of the racket is indicated by only two strokes, these strokes are critical—a slightly wrong placement would render the form incorrect, and a good tennis player would notice the mistake immediately.

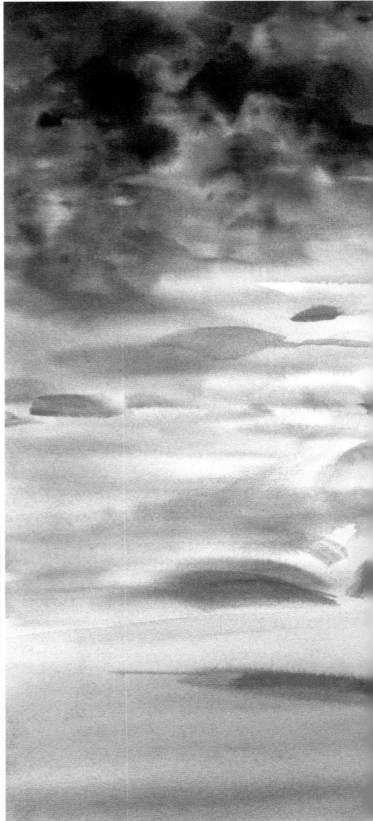

The Backhand *21" × 28" (53 × 71 cm), private collection*

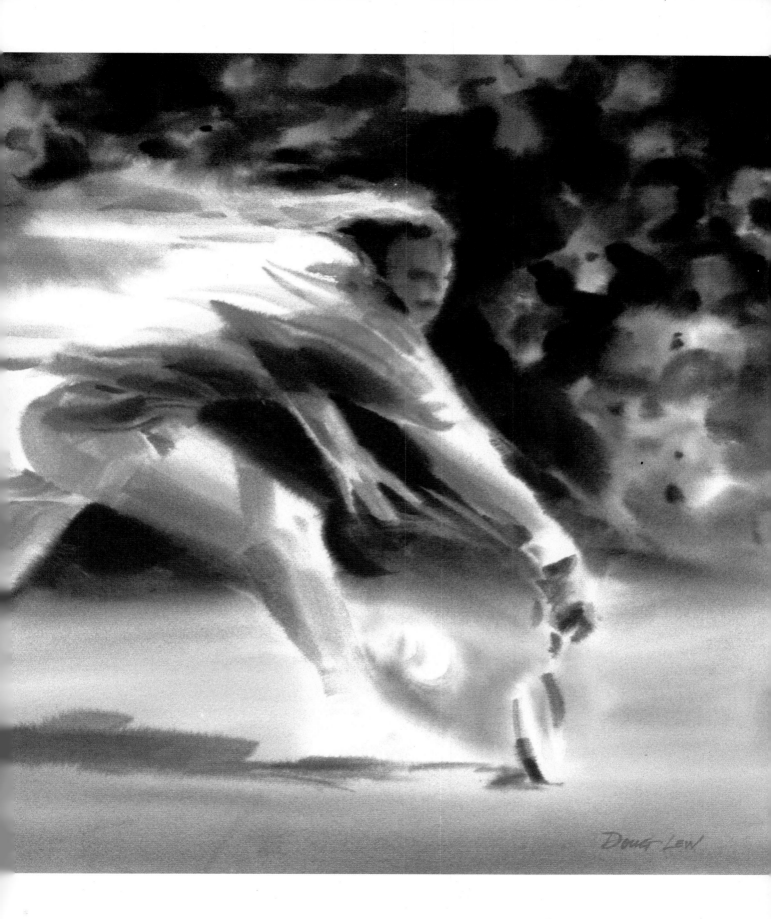

Capturing a Moment of Tension

Jump-All 24" × 36" (61 × 91 cm), collection of WUSA Broadcasting

How many times have you seen pictures of basketball players? Probably hundreds. I have always been impressed by the energy of those pictures.

To me, this jump-ball scene really is a peak moment of the sport, as two players stretch to their limits to get the ball while the other players wait in momentary suspension in a pyramid-like formation. I deliberately worked to make the players more abstract, blending them into the brushstrokes to help create the feeling of motion. Showing the ball was unnecessary. It would have looked too much like story-telling, which I wanted to avoid.

The hardest decision was where to place the jump-ball point. In the middle or off-center? The second hardest decision concerned the brushstrokes. Too much repetition would be monotonous. Too little would be odd. Ultimately, the answer lay in a probing process, in which I established the brushstrokes by feel more than by plan.

Beyond the composition, the painting stands or falls on how well the figures are drawn. At other times I have painted figures in the Western style, gradating the modeled figure with a brush. But here I want to "write out" the strokes, using them to convey motion. Look, for example, at the brushstroke that separates the two legs of the jumping player in the white uniform. See how the basic shape is repeated to the right, left, and below it? It also extends above it in a slightly different pattern to form the pants of the same player. Moving upward, you can see it again between his arm and his uniform. The same basic brushstroke also separates the two jumping players. And, continuing upward, it repeats itself in smaller light and dark strokes to form the muscular patterns of the two stretching arms.

I waited a few days before finishing this painting, knowing the danger of overworking it. More than once I have fallen victim to faulty judgment and spoiled paintings by overworking. When in doubt, it's better to leave it alone.

A Short Shot 22" × 16" (56 × 41 cm), collection of Terry Bremer

I'm particularly fond of this painting, not only because of the freshness of the brushstrokes, but also because it captures a momentary phenomenon—when a golfer tries to give a ball a higher trajectory than usual so that it will stop quick on landing. To do this, you play the ball from a stance a little more forward than usual, with your hands slightly ahead of the ball. I think I captured that stance here. A good golfer like my friend Terry knows what it's all about, and that's why he has the painting.

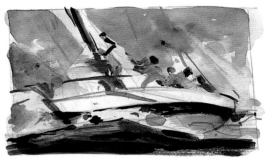

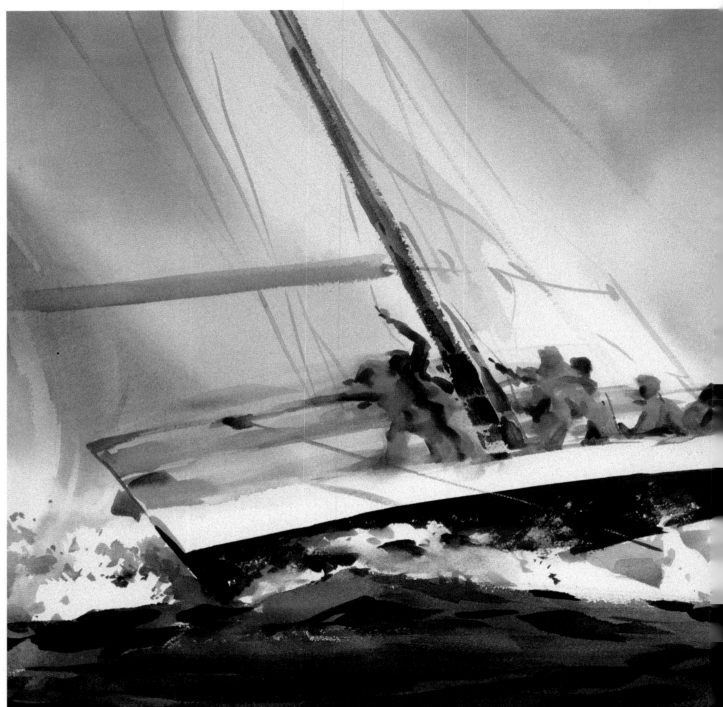

Men Against the Wind 21″ × 28″ (53 × 71 cm)

I did two color thumbnails for *Men Against the Wind* to make sure the tilt of the boat was steep enough and the water against its side broke up in an interesting way, giving a sense of motion. I liked the feeling of the wind lashing against the men, which I did with a little streaking, using a brush. For the color of the sky, I found a compromise, in between the two sketches. The water spray was done by scraping and scratching with an X-acto knife. If only all my water could be as good as this.

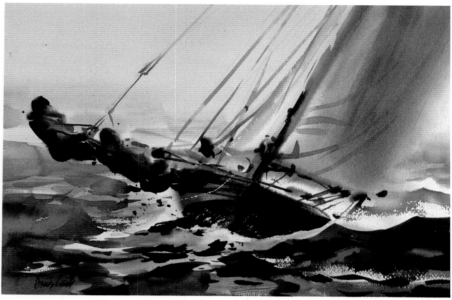

Two Hiking 16" × 22" (41 × 56 cm), collection of John Vaillant

The figures hiking, or hanging, out to balance a tipping boat provide a strong diagonal division of space. The large white sky dramatizes the thrust even more. The attitude of the bodies already has motion.

What I did was to make the water interesting and contrasty to play against the large sky and soft sail. Using a large, round Oriental brush, I worked in heavy sepia over a very light brown and orange underpainting of the water. The advantage of the Oriental brush is that you can cover a large area or do a thin line with the same brush. I thus vigorously applied strokes to depict the waves, two bodies, boat, and rope lines—almost all at once. A good example of calligraphy.

Look at the pitcher's stance. Doesn't he look like a cocked gun ready to be fired? His body has energy even without blurs. I put the movement in the crowd and connected it slightly to the left and right sides of the pitcher's body. I thought it would help the feeling of movement, without popping the pitcher out too much.

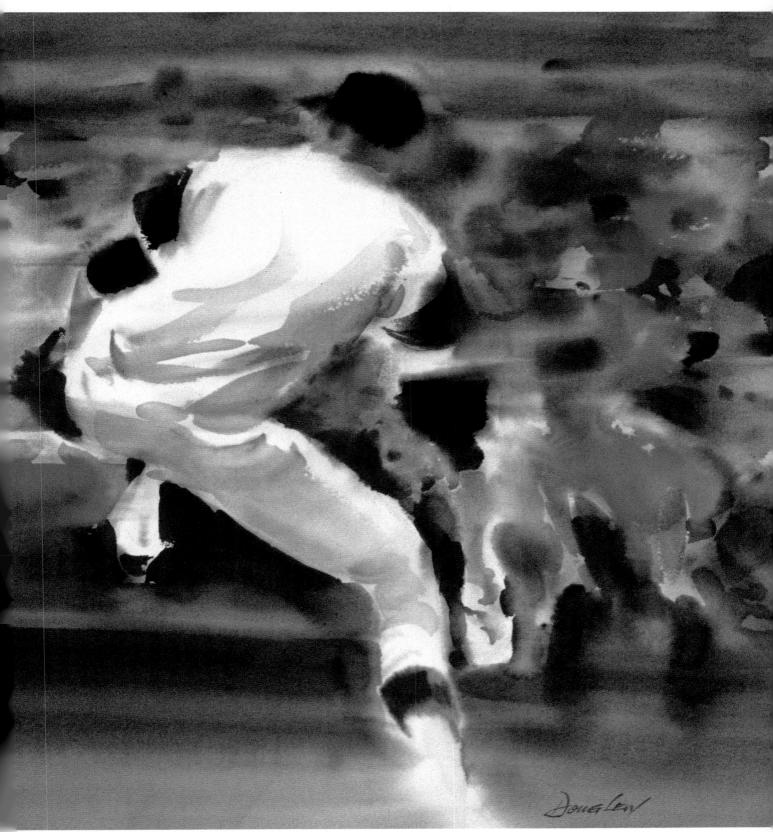

The Pitch 22" × 28" (56 × 71 cm), courtesy of C. G. Rein Galleries, Minneapolis

Conveying Excitement

Lake Placid, 1980. In an incredible show of determination, a bunch of young American amateurs beat the Russian pros. What a moment! I have it on tape, and it's still a thrill to see those ice-hockey players scrambling on top of each other, with the crowds cheering and flags waving.

As soon as I did the color thumbnail, I knew the hardest part would not be capturing the motion but painting the crowds. I saw the motion as a blur of red, white, and blue with figures minimally suggested. But how was I to integrate these figures with crowds and flags? That would be the key to the painting.

What I did was to use the white of the outstretched arm of a player and extend the white gradually into the crowd and to the flag. Without this connection, the crowds and the players would be too sharply divided. Once again, doing a color thumbnail paid off.

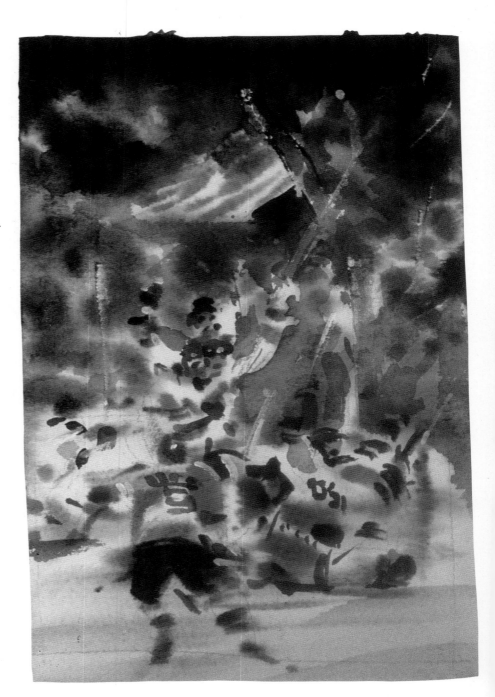

Lake Placid, 1980 36" × 24" (91 × 61 cm)

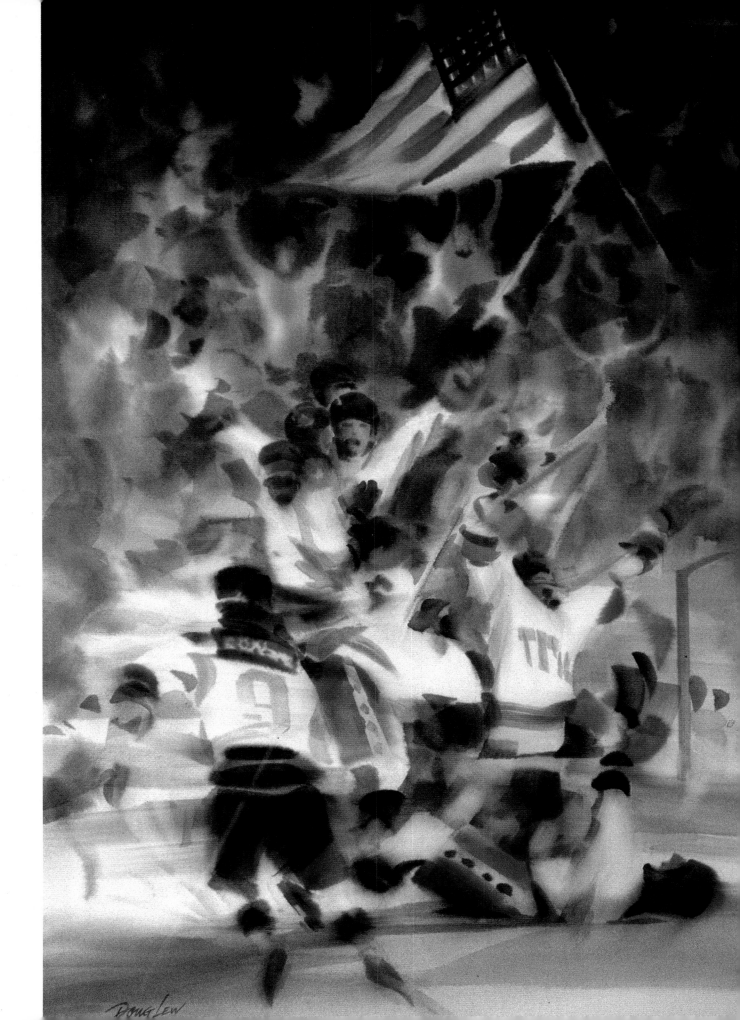

When I was a young boy in Shanghai, I went to my first American football game, played by the Fourth Marine Division on the fourth of July. Because my seat was quite a distance from the playing field, I never once saw the ball. All I saw was a jumble of bodies piled on top of one another every minute or two. I left bewildered. Then I saw the movie *Knute Rockne* and came to understand the game a bit better.

Now I watch Monday Night Football quite often, cheer the Vikings, and boo the wrong calls. I especially like the "football highlights," when critical moves are instantly replayed in slow motion. A running 200-pound athlete can take on the grace of a dancer.

In this painting I used different uniform colors to avoid any obvious identification of teams. To keep hard edges to a minimum, I worked wet-into-wet almost to the end. Motion is suggested mainly by the arms of the player on the extreme left.

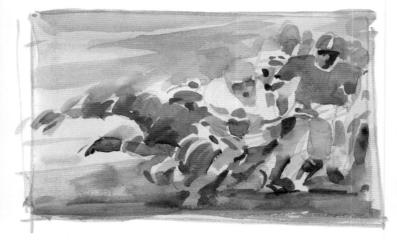

Third Down 22" × 28" (56 × 71 cm)

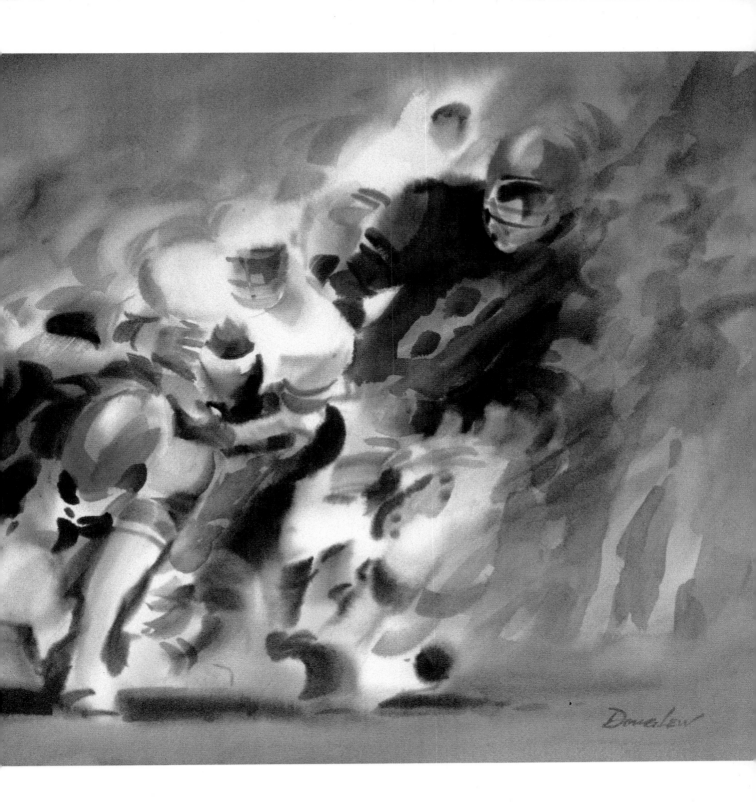

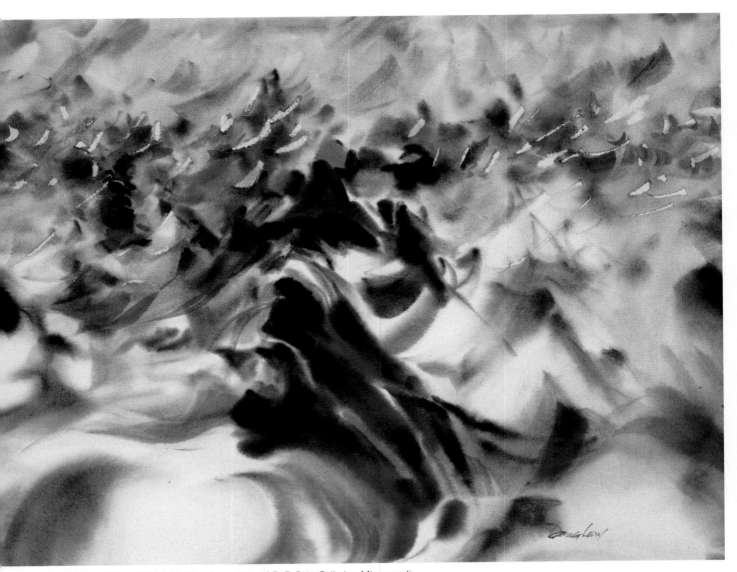

Carabiniere 22″ × 28″ (56 × 71 cm), courtesy of C. G. Rein Galleries, Minneapolis

The Italian police can put on a very fancy parade, dressed in colorful uniforms on horseback. How could I resist such a sight—especially, in terms of motion?

Notice, throughout the brown area of the painting, the generous use of scraping done with a painting knife. These marks repeat and complement the direction of the brushstrokes, starting at the top of the painting. I wanted to minimize the horses' prominence, so I worked with soft strokes. If you look closely, the body of the painting is a mass of brushstrokes, all kept fairly wet. The overall effect, I hope, is of the horses slowly trotting by.

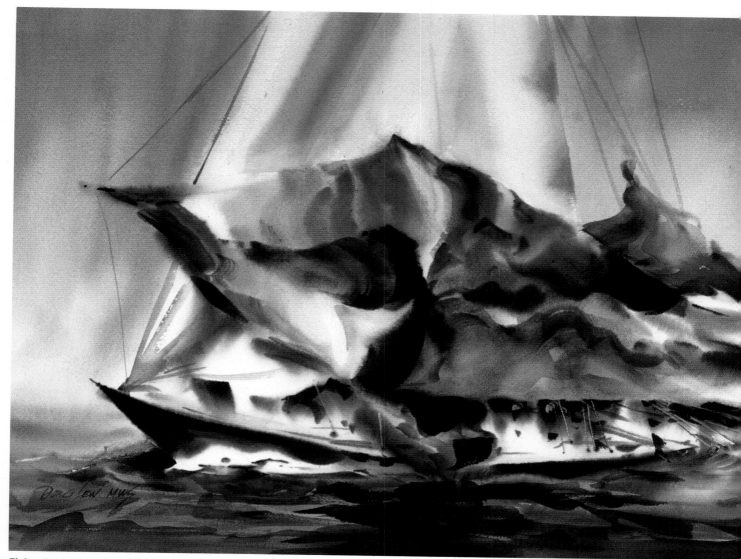

Flying Spinnaker 22″ × 28″ (56 × 71 cm), private collection

The waving of a large, colorful sail is always an eye-catcher. It reminds me of a contemporary art exhibit I saw in New York, where a small stream of air was released from the bottom of a sculpture and blew on a light, gently waving piece of colorful silk. The two corners of the material were secured by nylon strings attached to the base. The effect was mesmerizing.

As with most of my paintings containing motion, I use the wet-into-wet almost from beginning to end. A large, flat brush was used for the spinnaker. The details of the boat were kept to a minimum with the sharp point of the flat brush.

Choosing a Bold Composition

Bike Race over the Horizon 16″ × 22″ (41 × 56 cm), private collection

A severe division of space, such as the division in this painting, immediately creates interest. But how you sustain this interest is another matter. You've probably seen a lot of paintings with the horizon at the bottom and an intriguing treatment of the sky. I took a different route—putting the horizon very high and adding a blur of white, streaking motion to it. I like the idea that the viewer has to work a little to figure out what it is.

A strong division of values will always give you a bold composition. This time there is a sharp left/right division in the water, with the boat in the middle. If you use such a strong division, make sure there are subdivisions with subtle variations within to add interest and relieve monotony. Look, for example, at the light middle tones on the right and the smallish white waves on the left.

There is a lot going on in this painting, but it's not fussy. Although the figures in the boat are fairly well drawn, I dabbed them in wet-into-wet so they did not seem too sharp or too picky, as you can see in the detail.

This kind of painting takes a lot of energy—an inner energy of concentration and resolve. Concentrate on the vision you have in your mind. Resolve to let mistakes happen and be ready to start anew. Sometimes that's very hard to do—especially if half the painting contains some very good passages. You start to be more careful—and, when that happens, the painting becomes weaker.

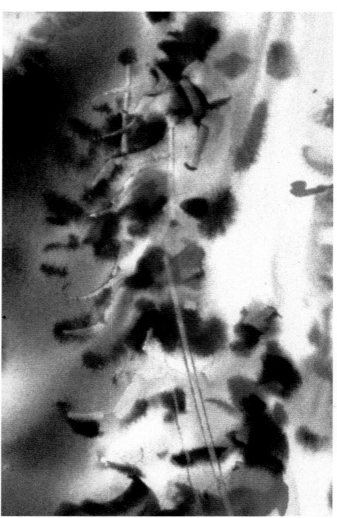

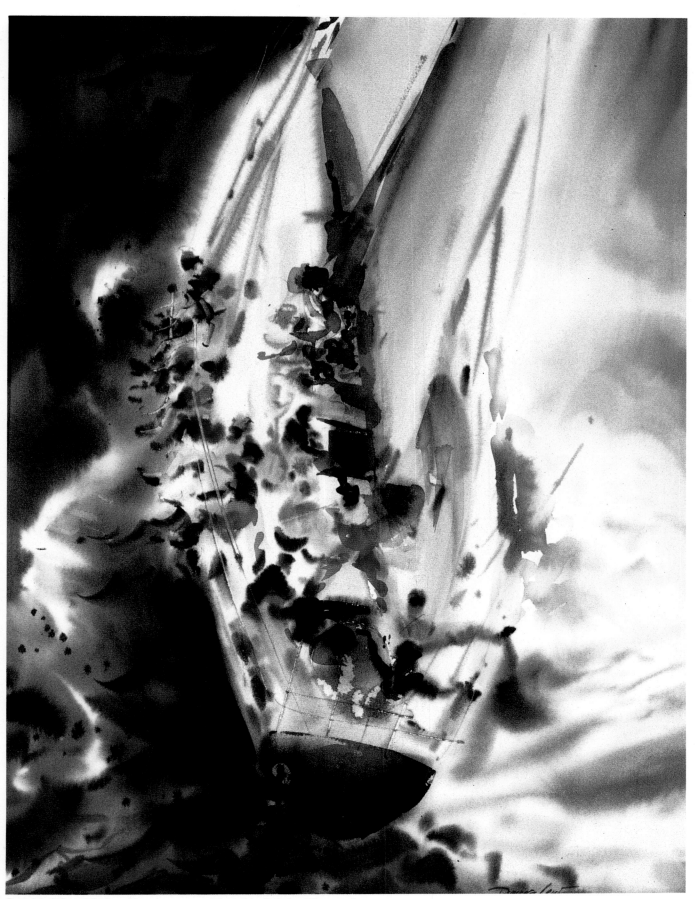

Portside 28″ × 21″ (71 × 53 cm), courtesy of C. G. Rein Galleries, Minneapolis

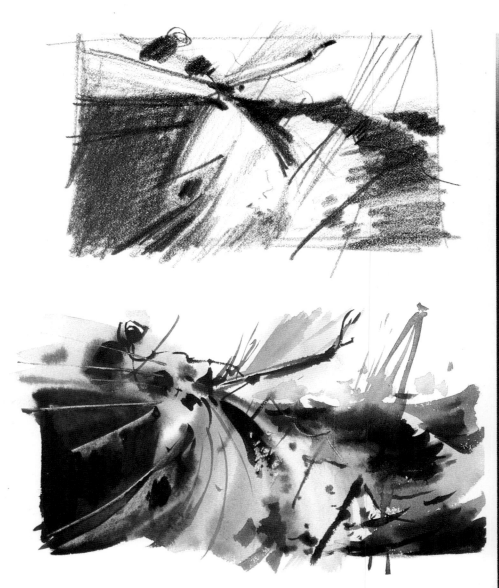

As you can see, even in the early pencil sketch the composition was interesting. I couldn't wait to get to the color sketch. From there to the painting, I made only minor adjustments: making the rectangular shape longer and the color a bit cooler. Actually the composition is so strong that as long as I kept the values shown in the sketch, I could paint this in a variety of color combinations.

The finished painting is actually a third try. I finally got the freshness I wanted by using a 3-inch flat brush for the broad areas—mainly the body of the boat at the left, the blue sail at the top, and the underpainting of the water waves to the right. I then used a smaller flat brush over the water waves and a large round brush for the final touches, such as the railings, the boom, and rope lines.

There are no blurs in this painting. Instead, the sense of motion is carried by the tilt of the ship, the heaving waves, and the crash of water against the ship.

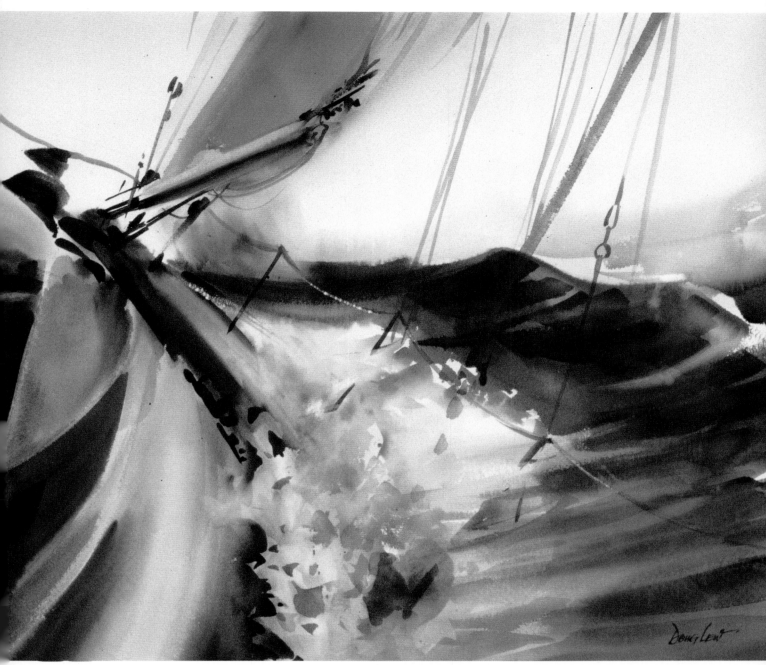

Ploughing Ahead 24″ × 37″ (61 × 94 cm), collection of John Meyer

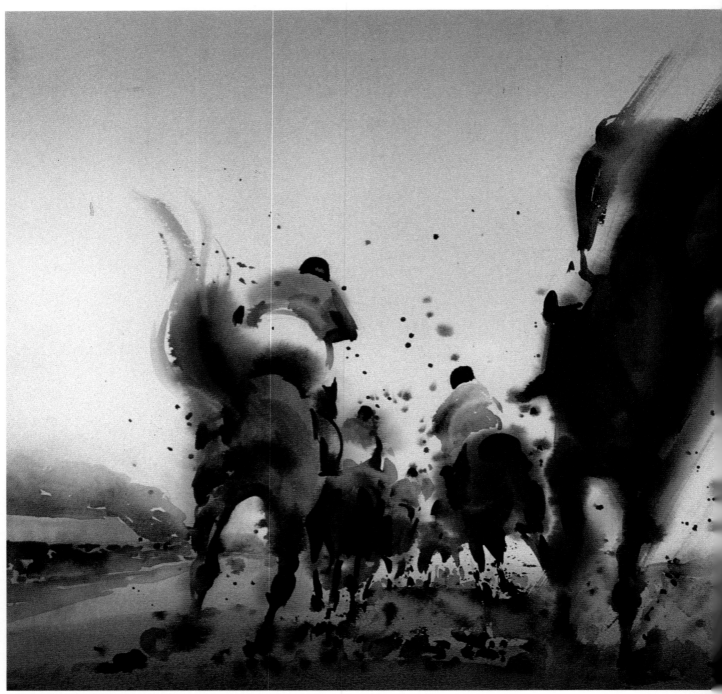

Horse Race—Back View *22" × 28" (56 × 71 cm), collection of Dr. Ji-Chia Liao*

One year I painted a lot of horse races; I had to title them specifically just to keep track of which was which. This ant's-eye view gave me a different angle for motion. I started the sketch in pencil, but added color at the last moment. I then skipped the color thumbnail and went directly to the painting itself, as the sketch seemed a sufficient guide.

The painting combines looseness with a feeling of detail—in part the result of the converging perspective of the distant horses. If you look closely, you'll see that the distant horses are not rendered any more tightly than the closer ones. But because they were dabbed in with smaller strokes, they appear tight. It's nice to have things happen by themselves.

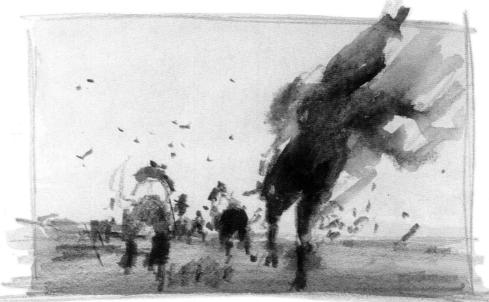

Strong composition can be achieved in a number of ways. One way is a bold division of space—in this case, white space. And what better way to do it than with a white sail?

Having set my composition in the pencil sketch, my next decision was how to develop this painting without losing the feeling of motion. It was a delicious temptation to play with small figures against the vast empty space. Well, I've fallen into those traps before. I finally decided to paint *alla prima,* or as near to that as possible, and let the details fall as they might. In other words, I was going after motion and energy. I used as few strokes as I could and did the whole painting wet to the end. When I came back to it the next day, I took one hard look and decided to leave it alone.

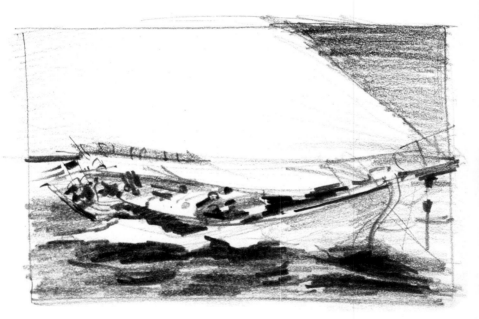

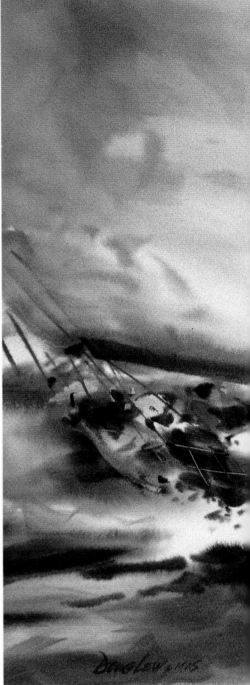

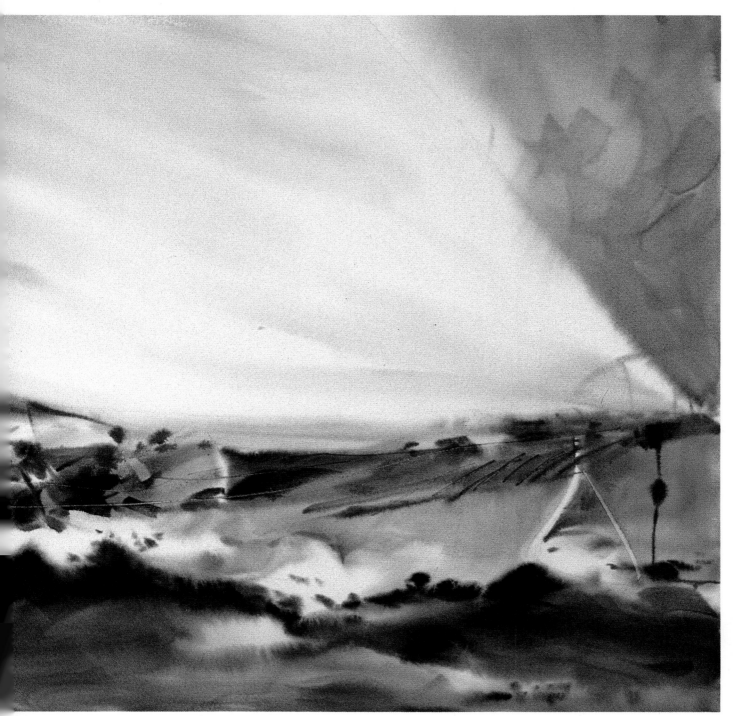

The White Sail 21″ × 25″ (53 × 64 cm), private collection

The diagonal division in this painting was an accident. It evolved from my sketch, in which the front sail seemed to continue down and connect with the nose of the boat. This connection gave the composition a strong direction.

Other decisions also flowed naturally from the sketch. The white space of the boat was so massive that I chose not to tamper with it. The feeling of the wind was so strong, it made my brushstrokes want to flutter with it. I also wanted to put my personal stamp on the painting—I wanted my drawing to show through. I picked the figure with his back to the wind.

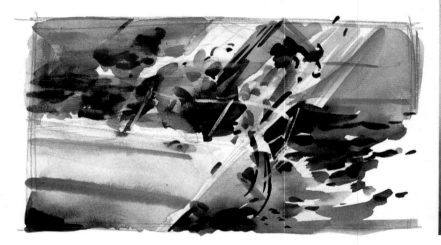

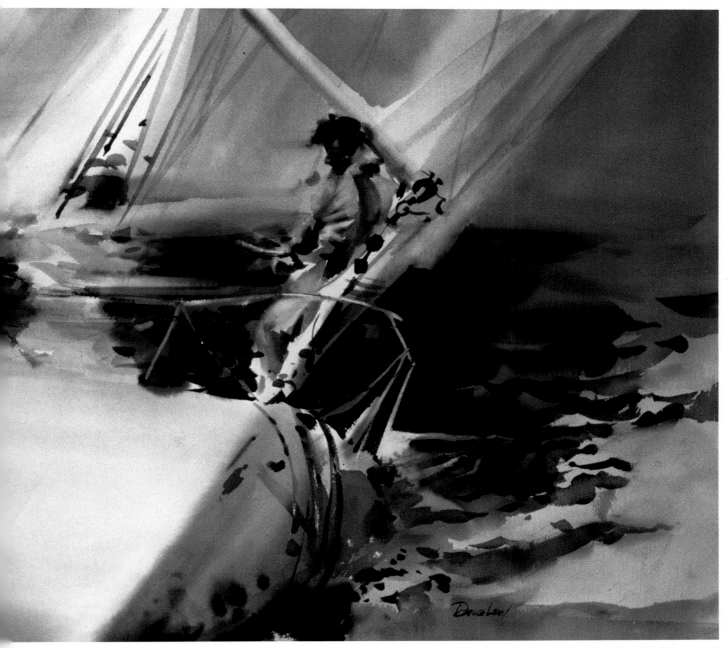

Untitled 36" × 24" (91 × 61 cm)

Getting It Right

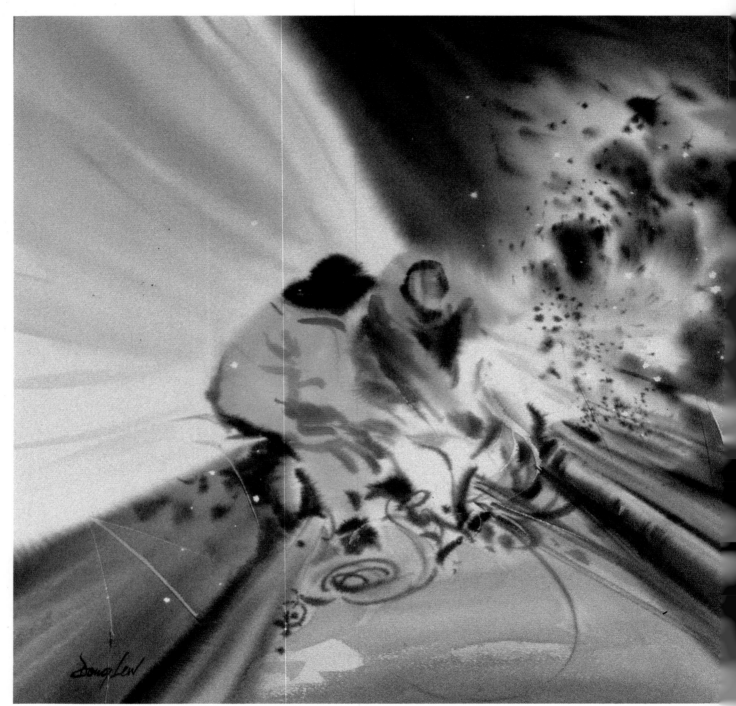

Fold Mast 16″ × 22″ (41 × 56 cm), collection of Harry and Marion Guest

First I did a pencil sketch to discover the correct poses for the figures. Then I worked on the color thumbnail to determine composition and color. Can you detect the influence of Turner?

I knew from the beginning that the turbulence of the water was going to be my challenge. The final painting shown here is my third try. At first I thought the turbulent water could be handled best with relatively hard edges. Wrong. The water took over the painting, and I spent too much time painting around the white foam at the expense of the picture's harmony. My second attempt was botched simply by overeagerness. I didn't wait long enough to put in the blue, and the color got out of control.

This time, the third, I made sure of the degree of wetness. I put in the large area of blue first, then splashed in a slightly stronger blue by gently tapping the brush against the handle of another one. I did it very close to the surface for better control. The farther away you are when tapping, the less you're able to control where the drops fall. I then used opaque white for more waterdrops, although this could also have been done by scratching.

Once the water looked right, the rest was much easier.

As a rule I usually move from pencils to color sketches to the final painting. By doing that I have managed to cut down the number of failures. My success ratio averages about one out of four attempts. I use the word "success" freely, knowing that what I consider success may not necessarily be regarded as so by others. I don't mind the failures, however, since most of my paintings are done quickly.

Anything can go wrong. Sometimes I start too soon on too wet a surface. Or I overwork an area too early. I may be in a state of mind that causes me to tighten up inside and lose spontaneity. Or a muddy palette may get into what should be a fresh painting. I'm sure you've experienced these pitfalls.

This painting actually failed six times, despite the fairly decent sketch. I was about to give up when I finally came up with the painting shown here. It kept the explosive energy of the horses in control. But I held onto the failures as a reminder to myself: "Be bold; be humble."

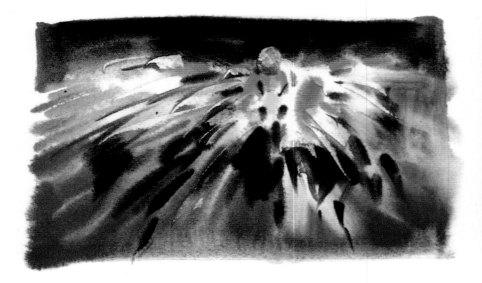

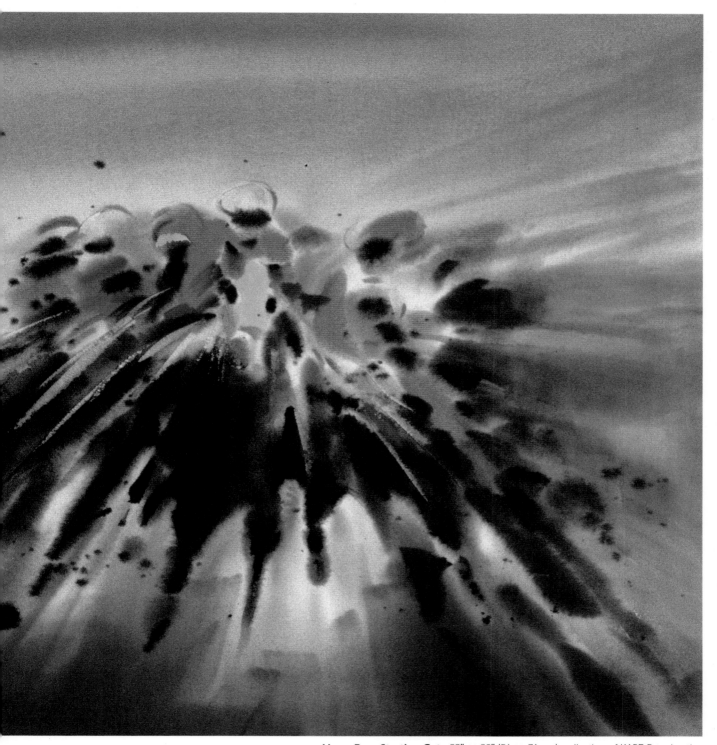

Horse Race Starting Gate 22″ × 28″ (56 × 71 cm), collection of KARE Broadcasting

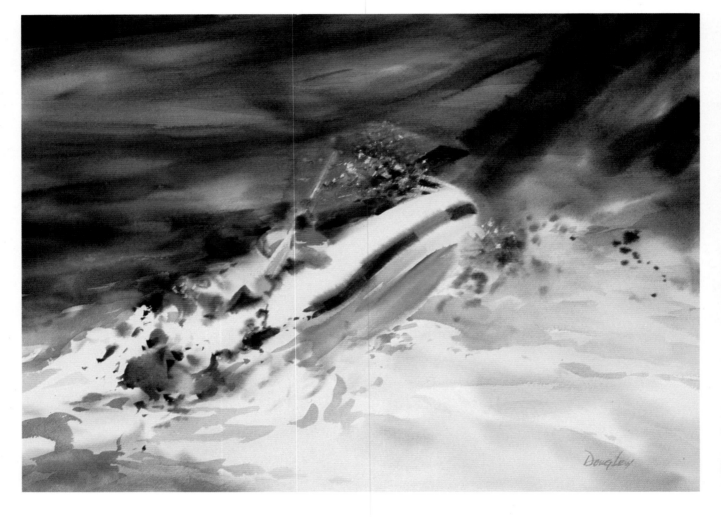

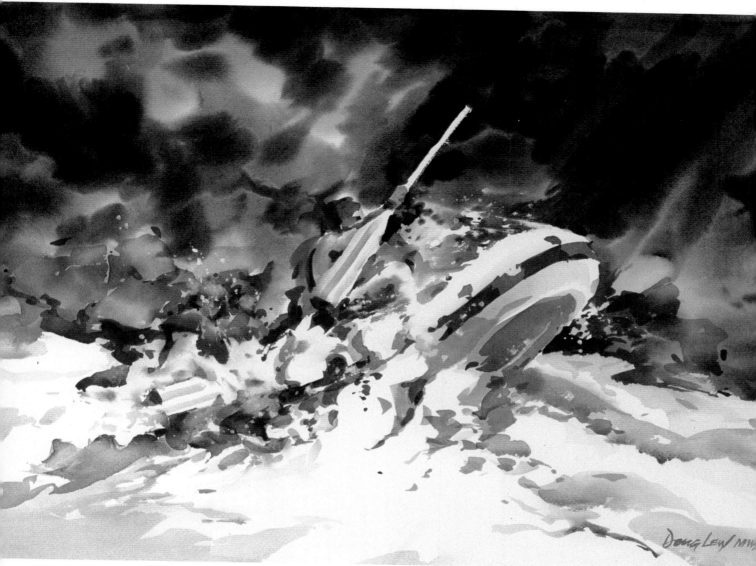

White Rapids 21" × 28" (53 × 71 cm), private collection

Most of the rapids I saw in Colorado were brown, but an artist is free to change this, making them white, or pink, or whatever. The two color thumbnails were done primarily to determine the background. As you can see, I wound up using a little of both.

In my first attempt at this painting, I worked wet from start to finish. The whole painting was soft, including the raft and the figures, with the water splash and drops left white and scratched out. Then I simply wanted a change. So I painted the background wet to suggest motion and the rest fairly dry. In this second version, the turbulence of the motion is more vivid.

Although 95 percent of my watercolors are painted without opaque white, this was one of the few exceptions. I could have masked the water as I did in my demonstration of the sailing race (pages 69–71) but I was in a hurry and didn't want to bother. Can you spot the opaques?

Suggesting Mood

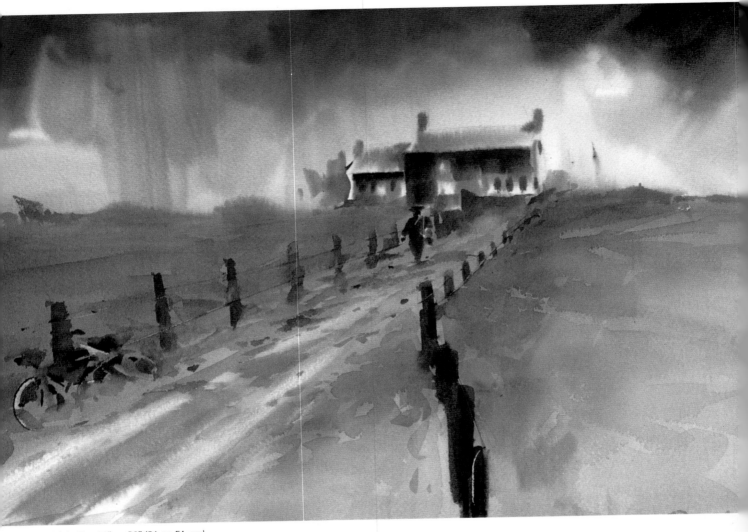

An Irish Sky 14″ × 20″ (36 × 51 cm)

The Irish sky can be very brooding and dramatic. It's the kind of sky that Claude Croney does so well. I have never had the pleasure of meeting him, but I have seen his work. This handling of the sky is a tribute to his teaching. I've minimized the definition of everything else so that the eye can dwell on the sky. And when you do that long enough it starts to move.

Steam Locomotive *14" × 20" (36 × 51 cm)*

A locomotive slowly chugging its way out of billowing steam is a nostalgic thing of the past. The contrast of the solid mass of iron shapes against the soft, moving steam made it an irresistible subject for me.

The final painting is a good demonstration of working wet-into-wet from start to finish. The sparse use of color adds to the hard structure of the train.

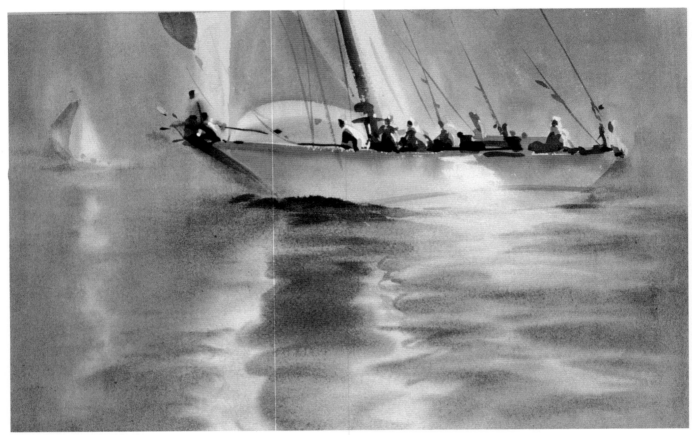

Sailboat at Sunset 14″ × 20″ (36 × 51 cm), collection of Maufred Bosier

I'm glad I placed the boat so high in the picture, as its reflection became an important part of the composition. Because of the color combination—yellow ochre and cerulean blue (both rather opaque)—the reflection might easily have become muddy. Careful timing and a clean palette were important to avoid this. I then waited for the reflection area to dry before painting the figures, mast, front sail, and lines.

The stiff sail says there's wind, but the gently moving water says the wind is soft. Notice how important the distant boat and its reflection are for a balanced composition. I handled these elements softly so they attracted just the right degree of attention.

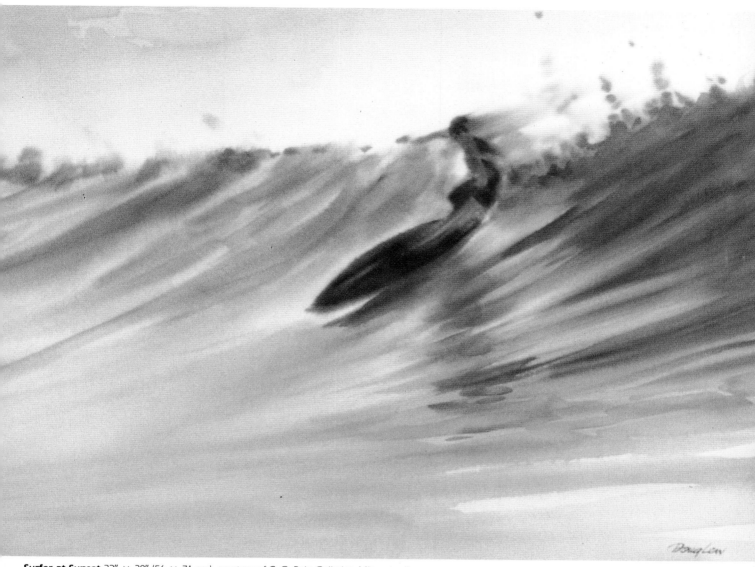

Surfer at Sunset 22″ × 28″ (56 × 71 cm), courtesy of C. G. Rein Galleries, Minneapolis

Like the sky, water can be painted every color of the rainbow. One of my favorite watercolor painters is Turner, and some of his most evocative watercolors are of sky and water. I'm still astonished to see the dramatic colors he used for the sky—pale yellow and touches of orange and scarlet. In his minimal indication of form he had no precedent. His watercolors are almost abstract but never totally. There is always a foundation of two phenomena: sky and water.

Turner never totally wet his paper as I have done in this painting. The wet-into-wet technique enabled me to keep sharp edges to a minimum—just the surfboard and a bit at the lower right. I used a tiny bit of streaking with the figure to add my own little touch—motion.

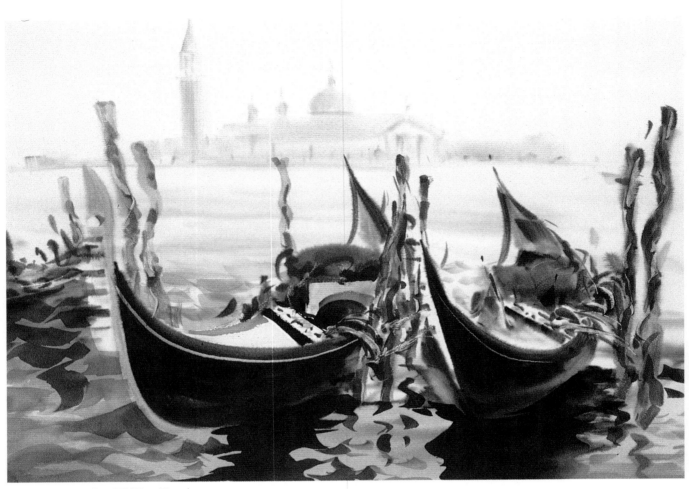

Two Gondolas 21″ × 28″ (53 × 71 cm)

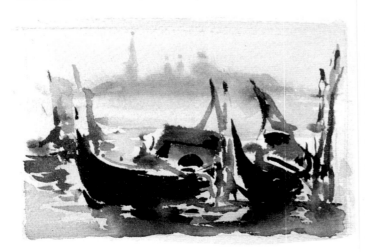

Now I understand why so many artists throughout the ages have painted Venice. Nowhere in the world is there a city like it. I had seen many pictures of Venice and knew what to expect, but I still wasn't prepared for the way the city was revealed to me. My wife and I approached it by train. When we stepped out of the train station with the crowd, it felt as if we were being spilled out onto the waters of Venice. The sights and sounds assaulted us all at once—the gondolas, bridges, churches, water bus, lapping water, and shouting people. At every turn there was a painting possibility.

This view of San Giorgio Maggiore in early morning has probably been done many times by other artists. The constant lapping of the water almost demands a quivering brush. I used both flat and round brushes here for the water and the gondolas.

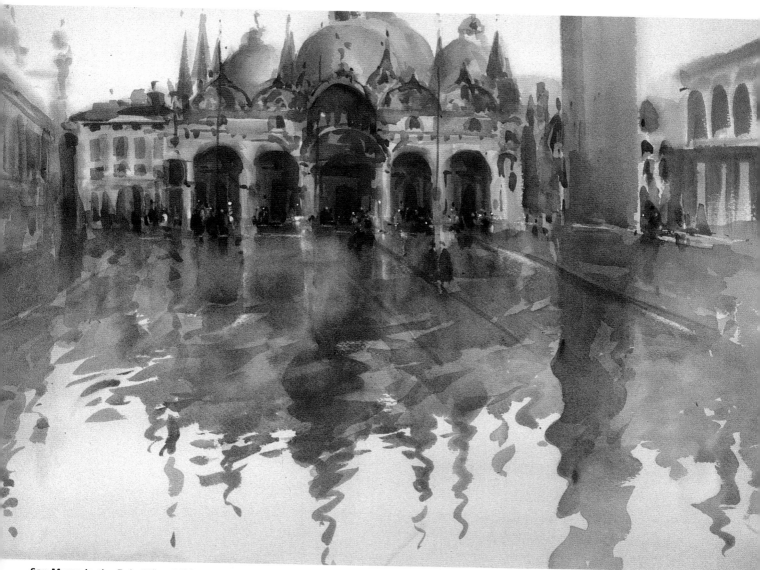

San Marco in the Rain *21" × 28" (53 × 71 cm), collection of KARE Broadcasting*

I have seen this huge piazza flooded knee-deep with water from the Adriatic. Wooden benches were laid out so people could walk on them from one side to the other. The water is not that deep here, but the square was wet enough for me to do lots of dancing with my brush. I love the contrast between the solid mass of the cathedral and the lilting movement of its reflection in the wet square.

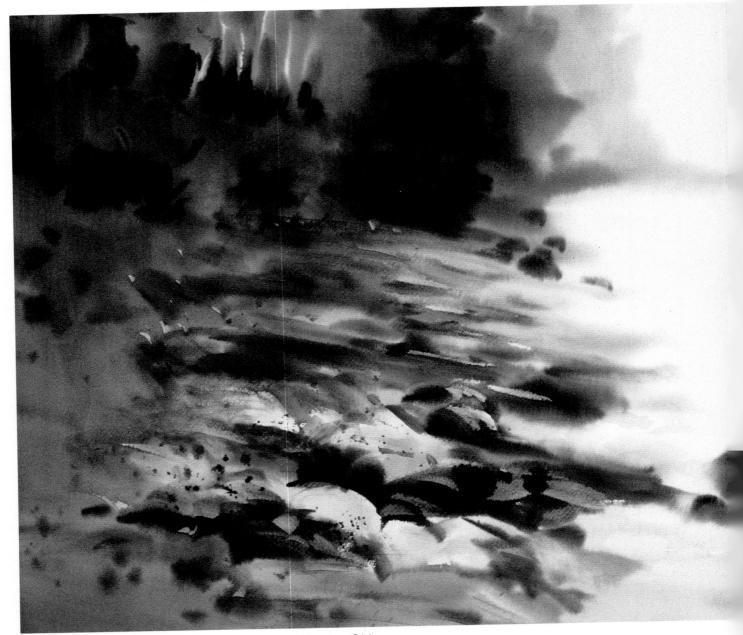

North Shore 23" × 35" (58 × 89 cm), collection of Steve and Mary Jane Griak

Two things stood out for me when I first saw the Minnesota North Shore: the ebony rocks made smooth by the ceaselessly pounding water and the oceanlike sound of Lake Superior. This area is beautiful in all seasons, especially when it's shrouded in fog.

With a large-sized painting like this, there's always a keyed-up anxiety before taking the first step. My thoughts concentrated on keeping it fresh and moody. After the initial passages of green and blue were quickly laid in, wet-into-wet, I could sense the mood emerging from the paper. At that point I discarded my thumbnail and went with the flow, letting the mood take over.

I was reminded of two lines of Chinese poetry: "When the falling clouds and a rising crane together took flight, /the sea and the sky became one and undistinguishable." I held fast to the mood and kept it simple, so there's force and lightness at the same time.

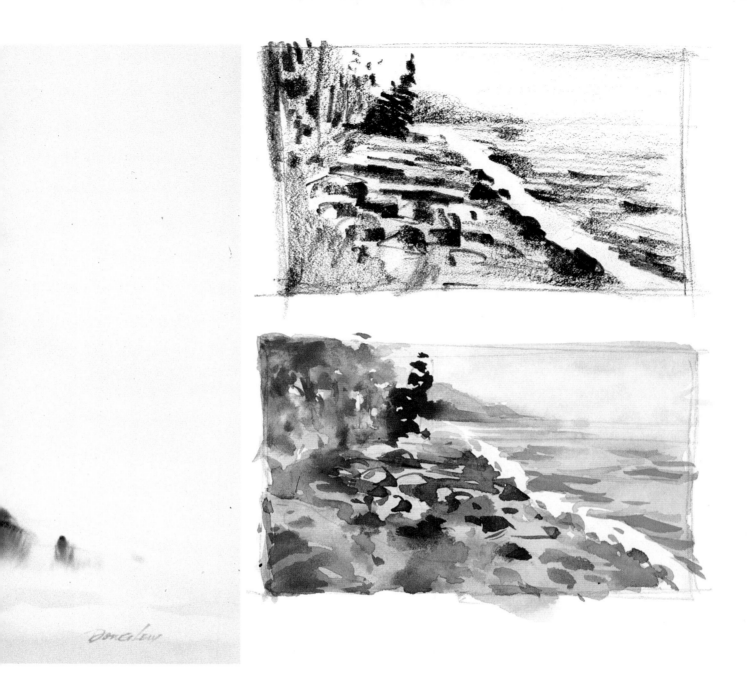

Using Calligraphy

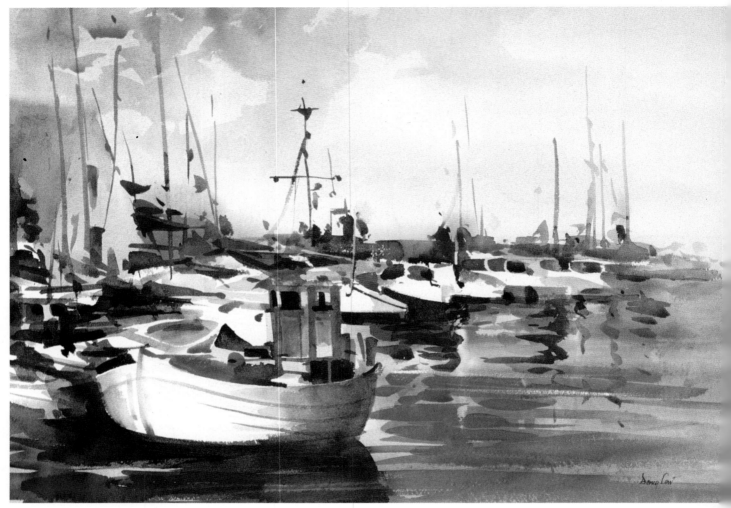

Paul's Landing, Lake Minnetonka 22" × 28" (56 × 71 cm)

This painting began as a demonstration of calligraphy to a small local art group. I still find the word "calligraphy" is widely misused and misunderstood. The Oriental definition is simply: "the art of brush writing." I find, however, that the word is used by art instructors to describe such things as the character, structure, and foundation of a painting. I know words do evolve into different meanings, but when the art class wanted a demonstration of calligraphy I understood this as painting a picture with obvious brushstrokes.

Look at the painting closely to see how almost everything is done with obvious brushstrokes. When the brush is this lively, it creates motion of its own.

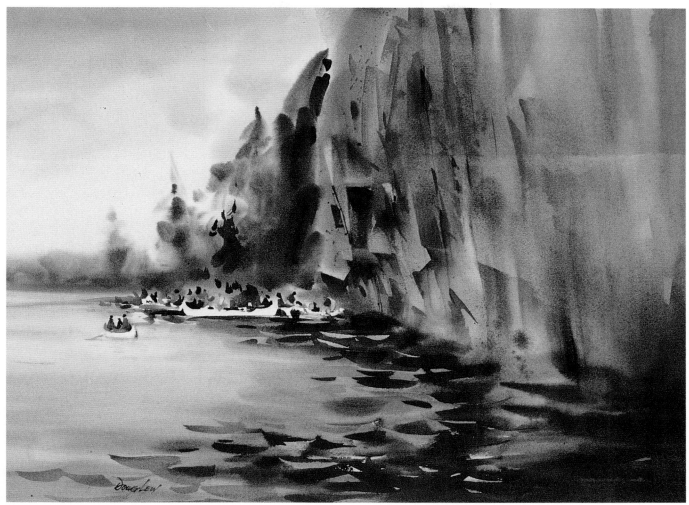

Taylor's Falls, Minnesota *21" × 28" (53 × 71 cm)*

Taylor's Falls is a popular place for Twin Cities watercolor painters because, in summertime, rock climbers, paddleboats, and canoes abound. I find the steep cliffs a difficult subject to paint. After many tries I decided to approach them with a flat brush. I continued using the flat brush in the water, slanting the brush downward, with the tip pointing toward me. This treatment gave the water a lot of movement, and it integrated well with the cliffs. For the trees and the canoes, I switched to a round brush, and again the lively brushstrokes created movement by themselves.

This painting demonstrates the use of the wet-into-dry technique in several layers, with the final stage drawn with a brush. This method takes longer than the wet-into-wet technique because each stage should dry completely before you apply the next layer. The value changes are very subtle, but the calligraphy is quite evident because it's done on top of a dry surface.

This traditional watercolor method was used by such nineteenth-century British watercolorists as Cotman, Girtin, and Bonington. It's good to know a little about the history of watercolor, simply to know where you stand in the entire scheme. Innovation comes from knowing the past. Here I made sure I left my personal mark by using an abundance of lively brushwork.

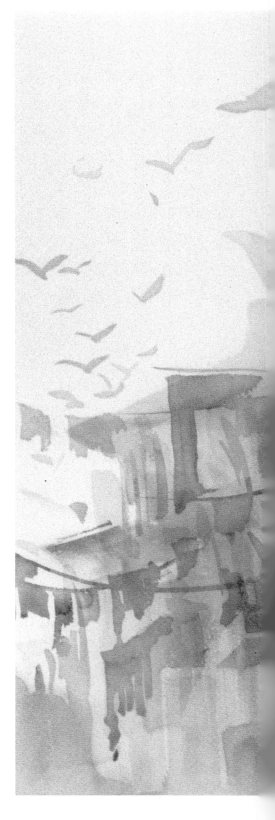

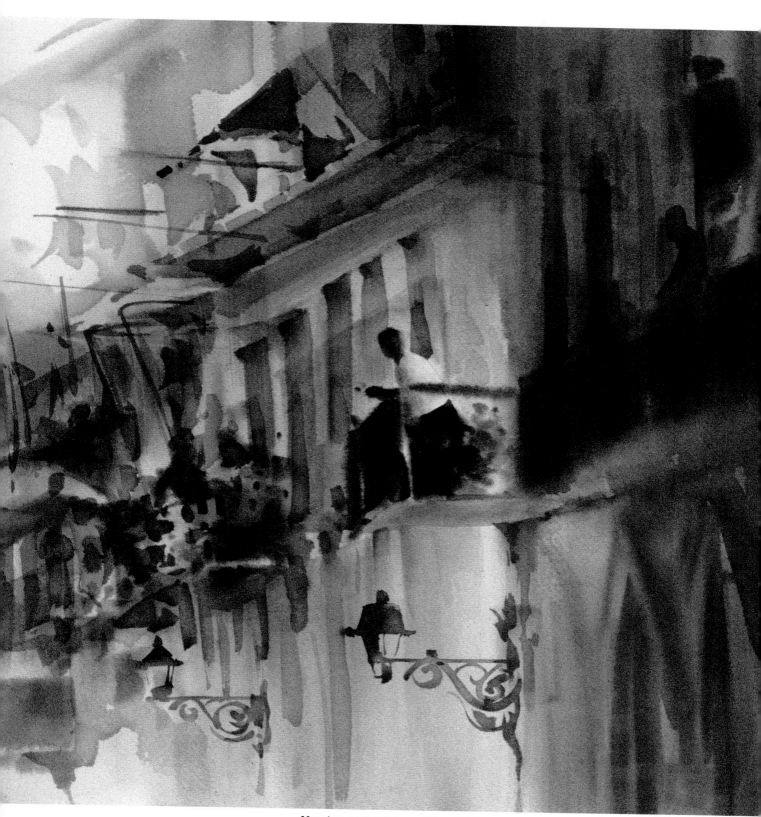

Morning on the Balcony 24" × 36" (61 × 91 cm), collection of Mr. and Mrs. Bill Johnson

A FINAL WORD

I feel like I have only reached a point somewhere on a long and pleasant journey with you—a journey of experiences shared, lessons learned, and goals to strive for. I don't have a sense of finality about this journey, because I'm still traveling, as you are, on a continuing quest started long ago by that person who first put paint on paper with a brush.

I'm happy to share with you a technique I accidentally stumbled upon. And that's all it is—a technique. Store it with other techniques and other information you'll gather along the way. Add them to strengthen and increase your own body of knowledge and experience. When we enrich each other, we enrich the world.

The Matador 20″ × 29″ (36 × 74 cm)

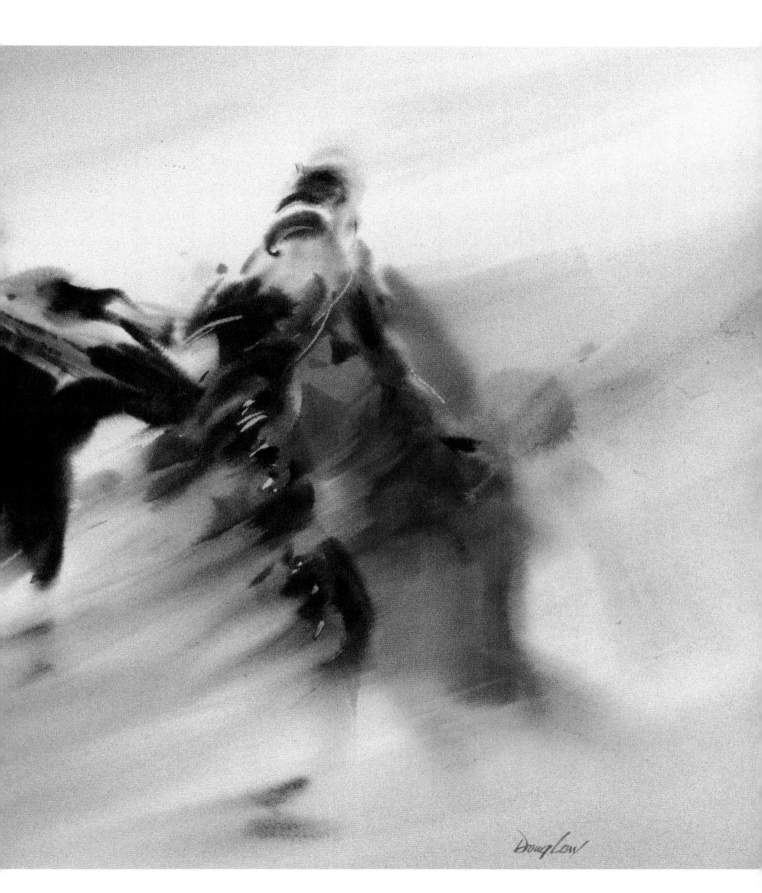

MATERIALS

My studio is in the basement of my house. Twelve years ago I gave the walls and ceiling a coat of off-white paint and installed two long fluorescent lights so I could work in it day or night. It's by no means ideal, but it's adequate, and I enjoy the hours I spend in it.

I use a pedestal-type drawing board, which I can tilt at any angle just by putting pressure on the edge. There are no knobs to twist or adjust. Watercolor waits for no one.

Brushes and Paper. Over the years I've accumulated a lot of brushes, but the tried-and-true ones are shown in the photo below. After a lot of experimenting, I've settled on 140 lb. rough Arches paper for most of my paintings. Because I usually work wet, I like to stretch the paper. I even stretch 300 lb. paper, but the only difference I find is that the 300 lb. paper stays wet a little longer.

Actually I don't use this weight often, because the advantages are not enough to justify the expense. Perhaps the thriftiness of my student days has stayed with me. Or perhaps the less expensive paper encourages a psychological abandon, making me feel free and daring—free to make mistakes and free to throw the paper away and start again.

Palette. I use all brands of paint—I don't really have a strong preference for one over another. What I've found is that the more expensive brands contain stronger, more concentrated pigment, so they last longer than the less expensive brands. As with all things in life: you get what you pay for. But no expensive paint has ever improved the quality of my painting.

For a long time I used a butcher's tray as a palette, but I find porcelain is still the best surface for mixing paint. For the last ten years or so I have

My tried-and-true brushes are, from left to right: an oil-painting bristle (hand-cut for lifting), another oil-painting bristle (also for lifting), an Oriental wolf hair, a no. 12 sable, an Oriental rabbit hair, a 3/4-inch nylon chisel-edge, a 1-inch nylon chisel-edge, a 1 1/2-inch oxhair housepainter's brush, and a 3 1/4-inch Oriental horsehair.

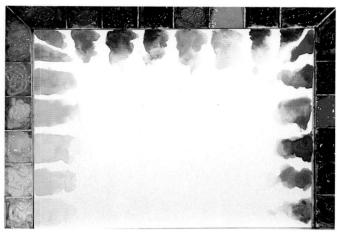

The colors on my palette are, clockwise from the lower left: lemon yellow, cadmium yellow medium, gamboge, cadmium orange, cadmium red light, cadmium red medium, alizarin crimson, burnt sienna, burnt umber, sepia, raw sienna, yellow ochre, ultramarine blue, Payne's gray, Prussian blue, phthalo blue, cerulean blue, Hooker's green dark, Hooker's green light, and viridian.

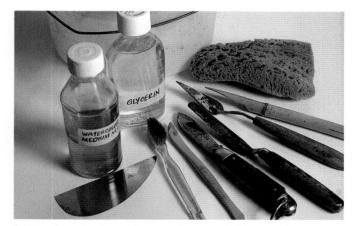

Most of my tools are for scraping, scratching, and splattering, although as time goes on I use these less and less.

been using the John Pike palette. It's such a sensibly designed palette, so portable, and—best of all—it keeps the paint moist. Very roughly, I arrange warm colors on one side, cool colors on the other side, and earthtones in the middle.

Mediums and Tools. I use two plastic containers for water, as one is simply not enough to keep the brushes clean. With a good-quality sponge I can wet the paper in no time. Then I use either glycerin or Watercolor Medium No. 1 to keep the paper wet longer. On average I use a teaspoon of glycerin and apply it directly to a full sheet of paper, which has been already wet with a sponge. I then spread the glycerin evenly with a damp sponge. For scraping, scratching, and splattering, I use a variety of tools (see the photo).

Slide Projector. I have found a mirror screen that allows me to project a slide rear-lit in a brightly lit studio. I hesitate to make too big a thing about it, but I am fascinated by different ways of seeing things. The projector can, for example, throw a picture out of focus, reducing it to simple shapes and values. This can help you evaluate the picture's potential as a composition and decide on ways to improve it.

Here throwing a slide out of focus enables you to pick out the main shapes and values.

INDEX

Abstraction, 40–43
 of speed, 66–68
Animals, drawing of, 19–23

Backhand, The, 96–97
Bike Race over the Horizon, 110–111
Blurs, 34–37
Bonington, Richard Parkes, 138
Breaking Away, 93
Brushes, 142
Burton Cup Race, The, 71

Calligraphy, 7, 30–33, 136–139
Carabiniere, 108
Catch, The, 84–85
Chang Jui-Tu, 31
Chen Shen, 30
Children In The Field, 79
Chu Yin-Ming, 32
Colorful Bikers, The, 87
Composition, 48–55
 bold, 110–121
Cotman, John Sell, 138
Croney, Claude, 128

Degas, Edgar, 7
Drawing, 8–29
 animals, 19–23
 figures, 8–18
 inorganic objects, 28–29
 landscapes, 24–27
 thumbnails, 48–55
Drawing board, 142
Duchamp, Marcel, 7

Edges, soft versus hard, 38–39
Einstein, Albert, 80
Excitement, conveying, 104–109

Figures, drawing, 8–18
Flying Spinnaker, 109
Fold Mast, 122–123

Girtin, Thomas, 138

Golfer, 60
Gray Day at the Downs, 90–91
Greyhounds, The, 89

Handlebar, 68
Horse Race—Back View, 116–117
Horse Race in the Rain, 65
Horse Race Starting Gate, 124–125
Hurdlers, 81

Inorganic subjects, drawing, 28–29
Irish Sky, An, 128

Joy of Biking, 94–95
Jump-All, 98

Lake Placid, 1980, 105
Landscapes, drawing, 24–27

Matador, The, 140–141
Materials, 142–143
Mediums, 143
Men Against the Wind, 100–101
Michelangelo, 7
Minnehaha Creek in Winter, 6
Mistakes, reworking, 122–127
Mood, suggesting, 128–135
Morning on the Balcony, 138–139
Muybridge, Eadweard, 7

North Shore, 134–135

Palette, 142–143
Paper, 142
Paul's Landing, Lake Minnetonka, 136
Pigeons, 76
Pitch, The, 102–103
Ploughing Ahead, 114–115
Portside, 113
Pumping, 92

Remington, Frederic, 61
Rubens, Peter Paul, 7
Runners, 86

Russell, Charles, 61

Sailboat at Sunset, 130
San Marco in the Rain, 133
Sargent, John Singer, 93
Short Shot, A, 99
Slalom Racer, 83
Slide projector, 143
Snow Ghost, 88
Speed
 abstracting, 66–68
 conveying, 82–97
Steam Locomotive, 129
Step-by-step demonstrations, 56–79
 birds, 72–76
 figures, 77–79
 golf, 56–60
 horse race, 61–65
 sailing race, 69–71
 speed, 66–68
Streaking, 44–47
Surfer at Sunset, 131

Taylor's Falls, Minnesota, 137
Techniques, 30–47
 abstraction 40–43
 blurs, 34–37
 calligraphy, 30–33, 136–139
 edges, 38–39
 streaking, 44–47
Tension, showing, 98–103
Third Down, 106–107
Thumbnail sketches, 48–55
Tools, 143
Turner, Joseph Mallord William, 123, 131
Two Gondolas, 132
Two Hiking, 101

Untitled, 120–121

White Rapids, 127
White Sail, The, 118–119
Wyeth, Andrew, 14